D0782104

"This lovely book by Sr. Jeana Visel takes the reader through a well-rounded history of iconography, and it shows how the Western iconic tradition has been wider and more nuanced than often presumed. Visel argues powerfully here that deep iconic art has the charisma to bring grace to contemporary worship, just as it did in times past, and can serve as an ecumenical rapprochement, with Catholicism's iconic tradition standing in a median role between the Orthodox and the Protestant worlds in their different understanding of icons as gateways to divine grace. The text has been produced by Liturgical Press with a deep artistic sensibility: its numerous illustrations make it a beautiful thing to possess. A little treasure. Highly recommended."

—Archpriest John A. McGuckin
Nielsen Professor of Byzantine Christian History
Columbia University, New York

"Just as the words of Scripture have been carefully transmitted to us down through the ages, the icon likewise embodies our faith in wood and paint and shimmering gold. Jeana Visel gives us a well-grounded and insightful way to think about this traditional art form in new ways and its possible integration into Western worship. Visel's approach is enriched by the personal experience of being an accomplished icon writer herself. This book is a must for all who are interested in the integration of liturgy and the arts."

—Martin Erspamer, OSB
Saint Meinrad Archabbey

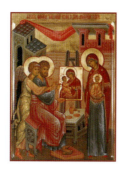

# Icons in the Western Church

## *Toward a More Sacramental Encounter*

Jeana Visel, OSB

**LITURGICAL PRESS**

Collegeville, Minnesota

www.litpress.org

|  | 4 | 5 | 6 | 7 | 8 | 9 |
|---|---|---|---|---|---|---|

**Library of Congress Cataloging-in-Publication Data**

Names: Visel, Jeana, author.
Title: Icons in the western church : toward a more sacramental encounter / by Jeana Visel, OSB.
Description: Collegeville, Minnesota : Liturgical Press, 2016. | Includes bibliographical references and index.
Identifiers: LCCN 2015048769 (print) | LCCN 2016008536 (ebook) | ISBN 9780814646601 (pbk.) | ISBN 9780814646847
Subjects: LCSH: Christian art and symbolism. | Icons. | Catholic Church —Doctrines.
Classification: LCC BV150 .V57 2016 (print) | LCC BV150 (ebook) | DDC 246/.53—dc23
LC record available at http://lccn.loc.gov/2015048769

# Contents

# Acknowledgments

Writing this book has been a great joy. Special thanks to Fr. Columba Stewart, OSB, who was willing to direct the project, and to Charles Bobertz and Sr. Mary Forman, OSB, of Saint John's University School of Theology for their encouragement. Thank you to Br. Aaron Raverty, OSB, Patrick McGowan, Lauren L. Murphy, Colleen Stiller, Hans Christoffersen, and all those who worked on this project at Liturgical Press for their assistance. I am grateful to Priscilla Fontechia, for teaching me the foundations of art; to Sarah Blick, for opening my eyes to art history; and to Stephanie Youstra, for cracking open the door to my first brush with painting icons. The most important aspects of iconography I have learned from master iconographer Ksenia Pokrovsky (d. 2013); her longtime assistant, Marek Czarnecki; and her daughter Anna Gouriev, of the Hexaemeron Six Days of Creation icon painting workshops, and words cannot express how much they have given me. Mary Lowell has been invaluable in making these opportunities possible. Jennie Gelles has provided hospitality and kindness. Marek has been helping me at almost every step of this project. I am grateful for the friendship, support, and challenge that have emerged from this community of iconographers. These

people have taught me so much about how to share a faith tradition with love and respect.

I am especially grateful to my religious community, the Sisters of St. Benedict of Ferdinand, Indiana, at Monastery Immaculate Conception, especially Sr. Barbara Lynn Schmitz, Prioress, for their support of my studies and this project. Thanks also are due to friends and coworkers at Saint Meinrad Seminary and School of Theology, who continue to challenge me to share the world of icons. For my family and all those dear ones who have helped nudge this book to completion, I give thanks to God.

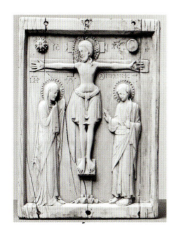

# Introduction

Despite a variegated and sometimes violent history, the icon has long held a place of honor in the Eastern tradition of Christianity. Venerated in churches, carried in procession through towns, and greeted with affection in homes, the icon in its original context speaks to the presence of God among us in the material world. The Greek word for icon, εἰκόν (*eikon*), literally means "image," "representation," or "portrait" and can refer to a wide array of religious images ranging from panel paintings on wood to frescoes, mosaics, embroidery, or even shallow carved relief or sculpture. Typically, however, an "icon" refers today to a portable image of Jesus, angels, or the saints, usually painted on a wooden panel, and used for prayer.[1]

1. Leslie Brubaker, "The Sacred Image," in *The Sacred Image East and West*, ed. Robert Ousterhout and Leslie Brubaker (Urbana, IL: University of Illinois Press, 1995), 3. For a more basic description of what an icon is, see also Thomas F. Mathews, *Byzantium: From Antiquity to the Renaissance* (New York: Harry N. Abrams, 1998), 43; Irina Yazykova, *Hidden and Triumphant: The Underground Struggle to Save Russian Iconography*, trans. Paul Grenier (Brewster, MA:

*Above: Carved ivory icon of the crucifixion. Walters Art Museum.*

In this study, I occasionally make reference to statues or other forms of religious images; when I use the term "icon," I am referring to portable panel paintings. Moreover, to say that the icon has flourished in the East is to refer to the geographical areas where Greek was the primary language in contrast with the Latin-speaking West. Though also a vast simplification, I speak of the East as referring broadly to the Orthodox form of Christianity, with the West referring to Catholicism.[2]

In the course of this book, I explore the question of what it means to embrace icons in the West, suggesting that for theological and ecumenical reasons, Catholics who would create or use icons need to know and give greater respect to the icon's Eastern tradition. In the first chapter, I explain what an icon is as understood from its roots in the Eastern Church. In its original context, the way an icon is created is linked to a deeper theological worldview. This theology is manifested in canonical

---

Paraclete Press, 2010), 1–26; Antonino Marino, *Storia della Legislazione sul Culto delle Imagini dall'inizio fino al trionfo dell'Ortodossia* (Rome: Pontificium Institutem Orientale, 1991), 39–43; Thomas F. X. Noble, *Images, Iconoclasm, and the Carolingians* (Philadelphia, PA: University of Pennsylvania Press, 2009), 28–31.

2. I do want to acknowledge that a number of Eastern Catholic churches follow the Eastern style of liturgy but remain in communion with Rome. Their theology, history, and culture make them in many ways aesthetically similar to the Eastern Orthodox Church. The Oriental Orthodox Churches, sometimes referred to as "Pre-Chalcedonian Churches," which acknowledge only the first three ecumenical councils, also bear a resemblance to the Eastern Orthodox Church. Much of what I say about icons in the Eastern tradition applies equally to each of these churches, despite their very real and important differences.

guidelines for icons and behavioral expectations held for iconographers. I also trace the basic historical development of the icon and its reception into the tradition. An introduction to some of the currents contributing to eighth- and ninth-century iconoclasm lays a foundation for comparison with later iconoclastic movements in the Western Church. I also show how icons have come to be an essential part of Eastern liturgy and devotion.

In chapter 2, I outline how icons came to be received in the Roman Church through medieval artistic exchange and how, in the West, the icon gave way to a different tradition of devotional art. In some ways, the Catholic tradition appears quite dissimilar from that of the Orthodox; for example, where the canonical icon depicts the world of heaven, the Western *memento mori* image aims to depict death in order to remind the faithful of the fleeting nature of human life and the importance of preparing for heaven. In other ways, however, the two traditions are similar; images in both East and West have been connected with miracles, relics, and access to the sacred. I conclude with an examination of how the Roman Church regulated images through the early modern period.

In chapter 3, I continue to explore the Catholic use of images in prayer and worship, analyzing how Vatican II came to promote an ideal of "noble simplicity." Intertwined with the emergence of modern art, this ideal in many ways has shaped more recent church art and architecture, as seen in church documents providing guidelines for sacred art. I argue that while the implementation of liturgical reforms brought some great advances to the experience of liturgical prayer, in the transition, in too many cases, meaningful, recognizable sacred art also was lost. I then examine how

icons begin to fit into the Catholic world redefined by Vatican II.

Chapter 4 provides an argument for why the Western Church can and should embrace icons as part of our theological and historical patrimony. Here I delve more deeply into the Eastern understanding of what an icon is in order to examine how icons could function more clearly in Catholicism. Of particular import is how the Eastern sense of sacred presence in icons is paralleled by the Western understanding of sacramentality. How are the saints or Christ present in their icons? I attempt to tease out whether the icon is more *sacrament* or *sacramental*, arguing that while it shares in the definitions of both, the icon tends toward being a sacrament in the broad sense of the word. Having established some foundation for perceiving the sacrality of icons in both East and West, I then explore how the Catholic Church understands and affirms the idea of venerating icons.

In chapter 5, I explore ways that the Catholic Church could better integrate icons into its living tradition. Drawing on Denis McNamara's categories of liturgical, devotional, and historical art, I suggest how the icon could function in each of these ways while remaining true to the ideals of Vatican II. I also examine how the icon might fit into the diversity of art that already exists in the Catholic Church, recommending some level of catechesis to help Catholics better understand the differences between icons and other kinds of sacred art.

Chapter 6 provides an exploration of some of the ecumenical implications of a greater Catholic embrace of icons. Because of their Eastern roots, icons intrinsically are a point of engagement between Catholicism and Orthodoxy. Given

the vicissitudes of our shared (and divided) history, however, respectful sharing between the traditions is not always easy. I argue that Western engagement with icons must be taken up with utmost respect for the Orthodox tradition, analyzing some of the effects of more recent Catholic attempts to use icons for different purposes. I then turn to how Catholic use of icons may affect relations with Protestant denominations. Tracing historical developments that have shaped Protestant views on religious images, including Reformation iconoclasm, I explore some of the reasons for recent Protestant interest in icons and other images. Ultimately, I suggest that icons constitute an excellent ecumenical meeting point for Catholics, Orthodox Christians, and Protestants. Studied, created, and used with respect, icons comprise an important part of the common Christian tradition, offering a worthy point of departure for further theological dialogue.

It is my hope that this study will engender further dialogue about the importance of quality images used for prayer and liturgy. In such a visual culture as our own, when we are bombarded with images that propagate knowledge of violence, lust, and greed, we stand in need of holy images. It is my belief that, in a mysterious way, icons have the power to help heal our brokenness. In the peaceful gaze of Christ and the saints, icons teach us to see with new eyes the dignity of the human person and the presence of God among us. It is this learning to see again with love that can bring about Dostoevsky's words from *The Idiot*: "Beauty will save the world."

# Abbreviations

| | |
|---|---|
| BLS | *Built of Living Stones* |
| CCC | *Catechism of the Catholic Church* |
| DPPL | *Directory on Popular Piety and the Liturgy* |
| DS | *Duodecimum Saeculum* |
| DV | *Dei Verbum* |
| EA | *Environment and Art in Catholic Worship* |
| EE | *Ecclesia Eucharistia* |
| GIRM | *General Instruction of the Roman Missal* |
| GS | *Gaudium et Spes* |
| LA | *Letter to Artists* |
| LG | *Lumen Gentium* |
| OE | *Orientalium Ecclesiarum* |
| OL | *Orientale Lumen* |
| PG | Patrologia Graeca |
| SC | *Sacrosanctum Concilium* |
| UR | *Unitatis Redintegratio* |

## Chapter 1

# Icons in the Eastern Tradition

Although traditionally associated with the Eastern Or-
thodox Church, in recent years, icons have become more
popular among people of Roman Catholic and Protestant
traditions. More and more, one may encounter icons of
Christ or the saints displayed in both homes and churches.
Courses on the theology and practice of painting icons are
multiplying, and museum exhibitions of icons or art in-
spired by icons have become relatively common. What is
this trend, and how are Christians to understand it? To
begin to explore these questions, it is necessary to study
the nature of the icon in its original Eastern context.

### What Is an Icon?

In the Eastern tradition, an icon makes dogmatic state-
ments in visual form. Thus the Orthodox speak of a "lan-
guage," "grammar," or "semantics" of iconography. Indeed,
in a strict sense, the artist does not simply paint but rather
is said to "write" an icon by using particular methods to
convey particular forms that fall within an accepted canon

of images. Just as the Gospel is the verbal Word of God, so the icon aims to convey the truth of Jesus.[1] Similarly, the "language" of an icon is inseparable from its narrative content. In many periods of history, the iconographic image was seen as educative, especially for the illiterate. Yet even beyond making statements of faith, the icon is an art form concerned with sacramental encounter with God. As Irina Yazykova writes,

> An icon brings the good news into the world by showing the face of Jesus Christ: God became man. Moreover, through Christ, the icon also reveals to us the true image of humanity transfigured and deified; it is the image of the kingdom of heaven, the kingdom that is to come and that will restore the harmony now marred by sin. . . . If an icon depicts a saint, its real purpose is to bring us face to face with someone in whom Christ's goodness shines forth.[2]

An icon usually depicts frontally a holy person confronting the viewer. In the very personal space between the person of faith and the icon, an exchange happens. One sees the image but also *is seen*. As Ernst Kitzinger describes it in his landmark 1954 essay on the cult of images, in the icon, "the distinction between the image and the person represented is to some extent eliminated, as least temporarily."[3]

---

1. Michel Quenot, *The Resurrection and the Icon*, trans. Michael Breck (Crestwood, NY: St. Vladimir's Seminary Press, 1997), 53.

2. Irina Yazykova, *Hidden and Triumphant: The Underground Struggle to Save Russian Iconography*, trans. Paul Grenier (Brewster, MA: Paraclete Press, 2010), 2, 4.

3. Ernst Kitzinger, "The Cult of Images in the Age before Iconoclasm," *Dumbarton Oaks Papers* 8 (1954): 101, as reprinted in Ernst Kitzinger, *The Art of Byzantium and the Medieval West: Selected Studies*, ed. W. Eugene Kleinbauer (Bloomington, IN: Indiana University

From the perspective of faith, particularly in the Eastern tradition, the holy person depicted is in some way understood to be *present*.[4]

## Painting an Icon

The sacrality of the icon for the Christian East means that painting it involves a process endowed with special care.[5] The first part of the process is preparation of the panel. Typically, the panel icon is painted on a board, usually made from a nonresinous wood. Often the back of the panel is reinforced with splines made of a harder wood to stabilize the panel and reduce warping. Some panels have a raised edge called

---

Press, 1976), 90–156. In this book, I will reference this work using the 1954 numbering, 83–150.

4. Michel Quenot, *The Icon: Window on the Kingdom* (Crestwood, NY: St. Vladimir's Seminary Press, 1996), 79.

5. Technical preparation of an icon varies; I share primarily the process I learned under the direction of Russian master iconographer Ksenia Pokrovsky and her assistant Marek Czarnecki of the Izograph School of Iconography during their Hexaemeron Six Days of Creation workshops in 2008 and 2010. I continue to work with Marek Czarnecki, usually from a distance. For more on technical preparation of an icon, see Marek Czarnecki, *The Technique of Iconography: Method and Teachings of Xenia Pokrovskaya and the Izograph School of Iconography* (Sharon, MA: Izograph Studio, 2003); Egon Sendler, *The Icon: Image of the Invisible*, trans. Steven Bigham (Torrance, CA: Oakwood Publications, 1999), 187–239; Quenot, *The Icon: Window on the Kingdom*, 83–119; Leonid Ouspensky and Vladimir Lossky, *The Meaning of Icons*, trans. G. E. H. Palmer and E. Kadloubovsky (Crestwood, NY: St. Vladimir's Seminary Press, 1982), 51–55; Gianluca Busi, *Il segno de Giona* (Bologna: Dehoniana Libri, 2011), 200–317. For a compilation of various ancient methods, see *The Painter's Manual of Dionysius of Fourna*, trans. Paul Hetherington (London: Sagittarius Press, 1974). Aiden Hart's *Techniques of Icon and Wall Painting* (Leominster, Herefordshire, Australia: Gracewing, 2011) is perhaps the most complete handbook currently available.

a *kovcheg*, which in Russian means "ark." This edge allows the painter to stabilize the wrist while working in the central part of the image without disturbing wet paint with one's hand. Historically, the *kovcheg* also functioned to protect the central image when icons were stored in stacks. The framing aspect of the *kovcheg*, moreover, marks the edge of sacred space within the artwork, like the frame of a window. The surface preparation of an icon panel involves sealing the wood with animal hide glue, then applying a piece of open-weave fabric to add stability and further prevent warping. The artist then applies many layers of gesso, a white substance made of chalk dust, marble dust, hide glue, and a bit of linseed oil and honey for flexibility. After it has dried, this stable surface is sanded to cool, hard smoothness.

A drawing of the image, usually taken from a traditional prototype, is then inscribed on the panel. Painting calligraphically with India ink over the drawing ensures that it will be a visible guide through the layers of paint to come. If the background or a halo is to be gilded, the artist may

*The initial stages of painting an icon involve preparing a panel with gesso (left) and inking a drawing onto the board with smooth, calligraphic lines (right).*

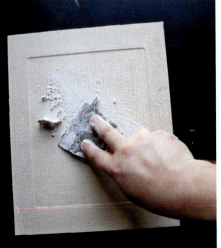
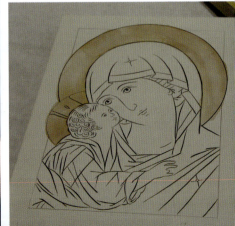

apply gold at this stage. Gilding with gold leaf can be done in different ways; generally the two options are "oil gilding" and "water gilding." Ultimately gold leaf is laid onto the surface in sheets; depending on the process used, it may be burnished or detailed before being sealed with varnish.[6]

While contemporary icons may be made out of any materials, traditional egg tempera paint is made by adding powdered earth pigments to egg emulsion. Usually gleaned from soil or crushed minerals, natural pigments are durable and many will not fade. Some minerals, like blue lapis lazuli, are rare and extremely expensive; others are common. Soil-based pigments reflect the specific terrain from which they were taken; the geographical source of some early icons can be identified from the particular shades of color used. Mixed with egg emulsion, the pigments make a smooth paint that in time will harden and fossilize. By adjusting the

---

6. On water gilding, see Sendler, *The Icon: Image of the Invisible,* 195–96.

*Gold leaf for gilding comes in small sheets, either loose (as pictured at left) or as "patent gold," which stays attached to its paper backing until applied. Oiling a completed icon (right) protects the surface and deepens colors.*

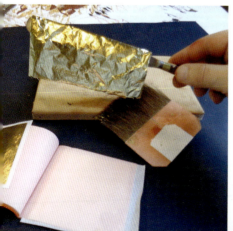
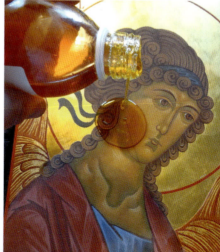

proportion of egg emulsion to pigment, the artist can create colors that range from sheer transparency to bold opacity.

The icon is painted in layers, moving from dark to light, from the least important elements to the most critical. The very process of painting mimics the deifying spiritual journey of the human person. Gradually being filled with the light of Christ, the Christian shares in the experience of the Transfiguration. The base layer is called *roskrish*, which is Russian for "opening up," "unveiling," "manifestation," or "appearance."[7] Beginning with the background, architectural features or other peripheral details, and then clothing, the artist adds layers of lighter tones that give definition and character. Finally the hands and ultimately the face are painted. The base tone for skin is called *sankir*, meaning "flesh." Reflecting the earthy beginnings of humanity in Genesis, this tone usually is a cool olive green. The next layer, beginning to articulate the broad areas of the face, is a warmer orange, representing the uncreated light of God illuminating the form. The artist then paints with even brighter light, adding layers of yellow ochre and then ultimately white as the features of the face and hands emerge and gain character with *ozhivki*, "enlivening lines." Sometimes the light of God is depicted visually by the use of gold *assiste*, a process of painting lines with gold.

This whole process comprises preparation for "the coming of the saint." Michel Quenot says that this is the moment the icon receives its *"presence."*[8] According to Egon Sendler, adding the inscription, giving the person represented a name, is the moment the painting becomes an icon:

> It is by the inscription that the image receives all its spiritual dimensions, its sacred character. . . . [T]he name is not simply a distinctive sign or title; it is a communion with

7. Czarnecki, *The Technique of Iconography*, 20.
8. Quenot, *The Icon: Window on the Kingdom*, 85.

the bearer of the name. Through the inscription, the icon is linked to its prototype, the person represented in it.[9]

In the Old Testament, the name of God (YHWH, meaning "I am Who I am," Exod 3:14) was seen by the Hebrews as being so powerful that only the high priest could speak it and live.[10] The name of Christ, likewise, is powerful. Early Christianity, particularly, recognized that miracles could be wrought by invoking the name of Jesus. According to Quenot, "The name of Christ is inherent to His Person; it actualizes His active presence which we are unable to see."[11] The saints, intimately joined to the Body of Christ in heaven, make the face of Christ present in their own.

Inscriptions also play a very practical role. It is important that icons be clear, accessible, and identifiable, with inscriptions written in a language people understand. If an icon is of a new saint, the title given functions as a sort of Church *imprimatur*.

### Canonical Guidelines

Because the Eastern Church takes sacred images so seriously, iconography is subject to canonical guidelines and episcopal oversight.[12] The canons of iconography are not promulgated via one central document but rather are the collection of various principles and Church teachings on the

9. Sendler, *The Icon: Image of the Invisible*, 214–15. For more on the development of using inscriptions on icons, particularly those identifying Christ, see Karen Boston, "The Power of Inscriptions and the Trouble with Texts," in *Icon and Word: The Power of Images in Byzantium*, ed. Antony Eastmond and Liz James (Burlington, VT: Ashgate Publishing, 2003), 35–51.

10. Quenot, *The Icon: Window on the Kingdom*, 85.

11. Ibid.

12. Ibid., 67–68.

traditional way a holy person or a particular scene is to be depicted in an icon. The first official canon, dating to the Acts of the Council of Trullo from 691–692, mandates that artists no longer depict Christ as a lamb but portray his humanity to depict the incarnation.[13] While those of the Western Church might see this kind of ruling as constrictive, Yazykova writes,

> The canon, rather than depriving the icon painter of freedom, more accurately holds up an ideal and a goal. The canon orients the icon toward a prototype. Properly understood, a prototype is more than just a pattern to copy: for the faithful, it represents something approximating the "true likeness" of embodied holiness. Reference to a prototype helps prevent iconographers from losing their way.[14]

Rooted in Scripture and coalescing in the ninth century with the conversion of the Slavic peoples, the canon "represents a central core of meanings that ensure that the iconic image is filled with the appropriate doctrinal and theological content."[15] These standards typically have been passed on through artists' manuals (in Greek, *hermeneia*), which, especially in the late Byzantine period, were used actively as reference books.[16] The most famous of these is the *Painter's Manual of Dionysius of Fourna*, compiled at

---

13. Ibid., 26; Thomas F. X. Noble, *Images, Iconoclasm, and the Carolingians* (Philadelphia, PA: University of Pennsylvania Press, 2009), 27. The Council of Trullo is also known as the "Quinisext," or "Fifth-Sixth," in that it added canons to the decisions of the Fifth (533) and Sixth (680) Ecumenical Councils. See Noble, *Images, Iconoclasm, and the Carolingians*, 26–27, regarding other canons of this council.

14. Yazykova, *Hidden and Triumphant*, 10.

15. Ibid., 4, 10.

16. Paul Hetherington, introduction to *The Painter's Manual of Dionysius of Fourna*, trans. Paul Hetherington (London: Sagittarius Press, 1974), iii.

Mount Athos probably between 1730 and 1734.[17] The oldest Russian manual is the 1552 *Usarov and Antoniev-Sisky Painters' Manual*, connected with the Synod of the Hundred Chapters, which aimed to reform sacred art.[18]

Canonical icons have certain characteristics.[19] The geometry of the composition is balanced, with forms and the proportions of the figure distributed in certain ways through the space.[20] Colors often have symbolism, and many figures are always depicted in clothing of a particular style and color. Because the holy person depicted now is in heaven, outside time, multiple scenes may be represented simultaneously on the same icon, with one event often revealing something of the meaning of another.[21] The figure is

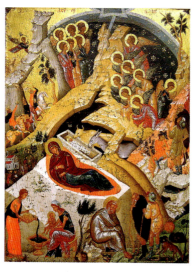

*In icons, multiple scenes may be shown at the same time, as in this image of the nativity. In the life of God, all time is present.*

17. Hetherington, introduction to *The Painter's Manual of Dionysius of Fourna*, ii; Quenot, *The Icon: Window on the Kingdom*, 68.

18. Konrad Onasch and Annemarie Schnieper, *Icons: The Fascination and the Reality*, trans. David G. Conklin (New York: Riverside Book Company, 1997), 236–37. The 1551 Synod of the Hundred Chapters also is known as the Stoglav Council.

19. See Quenot, *The Icon: Window on the Kingdom*, 66–72; Yazykova, *Hidden and Triumphant*, 2–10; Mahmoud Zibawi, *The Icon: Its Meaning and History* (Collegeville, MN: Liturgical Press, 1993), 50–58.

20. For more on proportions and geometry of icons, see Sendler, *The Icon: Image of the Invisible*, 87–118.

21. Yazykova, *Hidden and Triumphant*, 6.

represented within transfigured reality and so is depicted healed of any physical defects that may have been known in his or her life. While never destroying the individual person-hood of the one pictured, the saint is painted with idealized order, particularly visible in the flow of fabric and neatly arranged locks of hair. Light, too, is transfigured and is shown as coming not from an external source but from within the person. True shadows have no place in an icon because the icon represents the space of "eternal day," portraying "the uncreated light" described by Gregory Palamas, expressing the "divine energies that suffuse the whole world."[22]

The characteristic of canonical icons probably least understood by the West is the use of inverse perspective. Rather than objects in the background getting smaller as they appear farther in the distance, as in everyday depth perspective, in the icon, things at a distance get larger.[23] This is seen most obviously in furniture or architectural features. But it is also the reason why figures themselves can seem "distorted." What in ordinary view would fall out of our line of sight is in a sense flipped forward and made visible; from a frontal position, we see folds of gar-ments, locks of hair, and the bone structure of the body as they would appear viewed from the top or sides. We are seeing from multiple angles at once, and yet it is a coherent reality and not fragmented cubism that we behold:

> Everything . . . is so arranged that it enters into the view-er's field of vision. All lines converge—in terms of both their meaning and their geometry—in the spectator's

22. Ibid., 8; Sendler, *The Icon: Image of the Invisible*, 165–83.

23. Sendler, *The Icon: Image of the Invisible*, 119–48; Yazykova, *Hid-den and Triumphant*, 5.

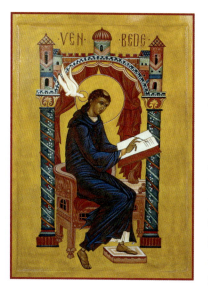

*In icons, the use of inverse perspective means all lines converge in the space of the viewer, rather than at a horizon line. This stylization is seen particularly in architectural details, such as in this icon of St. Bede. (Icon by the hand of the author.)*

prayerful gaze. Iconic space unfolds in all directions around the person who prays and draws that person into this space, where objects can often be seen from three or even four sides at once.[24]

Along with the use of light without true shadow, inverse perspective gives icons their sense of form without volume, shape without spatial depth, all on a flat plane.[25] It reflects for the Eastern church the icon's role as a window to the spiritual dimension, a sacred space that, rather than shrinking one's world, opens up into the mystery of God's infinity.

## The Iconographer

Given the sacramental nature of the icon, in medieval times the Eastern Church saw the vocation of iconographer to be something akin to priesthood, with similar standards for behavior.[26] Today, iconographers can be lay, monastic, or clergy, married or celibate. Yet the weighty task of the artist is to cultivate a deeper relationship between the viewer and the "true likeness of Jesus," creating an icon that will help the viewer become an icon of God. Writing icons was seen

24. Yazykova, *Hidden and Triumphant*, 5.
25. Ibid., 2–3.
26. Ibid., 37; Quenot, *The Icon: Window on the Kingdom*, 68.

by the church fathers as "the art of the arts," and a "process of doing spiritual work."[27] It is understood that every icon in some way reflects the spiritual state of the artist, of the Church of the time, and of the wider world in which the iconographer lives.[28] As the artist's own holiness is in some way made visible through his or her work, so the moral character of the iconographer needs to be proven pure.[29] According to the 1551 Stoglav Council held in Moscow,

> An iconographer shall be reverential, humble, not given to vain talk or clownery; not quarrelsome or of an envious nature; shall not be a drunkard, or a thief, or a murderer; most important of all, he must guard to the utmost the purity of his own soul and body, and whosoever is unable to endure in this state till the end, let him marry according to the law. The artist should regularly seek the advice of a spiritual father, listening to his counsel in all things and living accordingly, fasting, praying, and leading a life of restraint and humility, devoid of shame and disgrace. . . . If any master painter, or one of his students, should begin to live in a manner contrary to the rules . . . then the Church hierarchs are to place such persons under discipline, must forbid them from painting, and not allow them to [even] touch their paints.[30]

While the Eastern Church is known for a level of asceticism among the faithful in general, the demanding standards held for iconographers have meant that many painters over the years have been monastics.

27. Yazykova, *Hidden and Triumphant*, 10.
28. Ibid.
29. Ibid., 38.
30. As quoted in Yazykova, *Hidden and Triumphant*, 37.

## Historical Development of the Icon

Historically speaking, images have been part of Christianity from its beginnings.[31] Common Christian symbols like the fish, anchor, and lamb, as well as scenes from the Old and New Testaments, were painted on the walls of the catacombs. Kitzinger, writing before the wider world's discovery of the early encaustic icons preserved at the Monastery of St. Catherine on Mt. Sinai, sees early Christian art as being limited to a decorative function, reflective of a general "rejection of material props in religious life and worship" or anything that could be construed as an idol.[32] Ouspensky, however, is convinced that the first devotional images go back to the time of Christ, citing Eusebius's mention of "portraits of the Savior, of Peter and of Paul," and a statue of Christ ostensibly erected by the woman healed

31. For description of sources and the rise of early iconography, see Mathews, *Byzantium*, 43–52; Yazykova, *Hidden and Triumphant*, 15–17; Quenot, *The Icon: Window on the Kingdom*, 23; Kitzinger, "The Cult of Images in the Age before Iconoclasm," 88–95; Lossky and Ouspensky, *The Meaning of Icons*, 25–28; Noble, *Images, Iconoclasm, and the Carolingians*, 10–15; Averil Cameron, "The Language of Images: The Rise of Icons and Christian Representation," in *The Church and the Arts*, ed. Diana Wood (Cambridge, MA: Blackwell Publishers, 1992), 1–42; Hans Belting, *Likeness and Presence*, trans. Edmund Jephcott (Chicago: University of Chicago Press, 1994), 36–46.

32. Kitzinger, "The Cult of Images in the Age before Iconoclasm," 89. Regarding the "discovery" and first publishing of the Mt. Sinai images, see also Jeffrey C. Anderson, "The Byzantine Panel Portrait before and after Iconoclasm," in *The Sacred Image East and West*, ed. Robert Ousterhout and Leslie Brubaker (Urbana, IL: University of Illinois Press, 1995), 27–28; *Holy Image, Hallowed Ground: Icons from Sinai*, ed. Robert S. Nelson and Kristen M. Collins (Los Angeles: J. Paul Getty Museum, 2006).

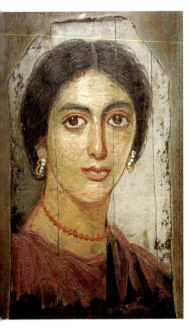

*Early icons bear a clear resemblance to second-century Egyptian wax encaustic mummy portraits.*

of the issue of blood.[33] Some of the earliest surviving icons, from the sixth century, reflect continuity with traditional images of pagan gods, before which devotees would light candles and burn incense. Other early icons bear a clear resemblance to the wax encaustic mummy portraits from Fayum, Egypt; the Fayum portraits depict an idealized version of the dead person, who was expected to be resurrected. Early Christian icons also appear to continue the Roman tradition of portraiture.

Old Testament prohibitions against venerating images, paired with a concern not to fall into pagan practices, engendered an early sense of unease with devotional practices involving images,[34] yet it seems clear that Christian sacred images were widespread by the fourth century. Lighting lamps and burning incense before imperial images was a fifth-century custom;[35] by the sixth century, such devotion to icons was common, both in homes and public places, and

33. Lossky and Ouspensky, *The Meaning of Icons*, 25.

34. Mathews, *Byzantium*, 45; Kitzinger, "The Cult of Images in the Age before Iconoclasm," 86–89; Brubaker, "The Sacred Image," 14–15; Anderson, "The Byzantine Panel Portrait before and after Iconoclasm," 24–27; Yazykova, *Hidden and Triumphant*, 17–18.

35. Kitzinger, "The Cult of Images in the Age before Iconoclasm," 98.

a letter from Bishop Hypatius of Ephesus to Julian of Atra-myton provides the first reference to *proskynesis* ("venera-tion," literally, "kissing toward" and sometimes including a full prostration[36]) to images in churches.[37] In the civil world, icons, especially of the Virgin Mary, became part of imperial ceremony. They were seen as legitimating rulers, protecting cities, and shielding soldiers in battle as *palladia*.[38] The protective function of icons reflected a grow-ing belief in the miraculous power of certain icons, such that some even thought that consuming scrapings from an icon could heal the sick.

36. *Proskynesis* is derived from a Persian practice of greeting each other with a kiss, bow, or prostration and giving respect to a person of higher rank. Greeks mistook this for honoring a person as a god; when taken into the Roman Empire, *proskynesis* was used to show tribute to the emperor in a way that would elevate him to the status of a god. In the Eastern Church, *proskynesis* refers to bowing or kissing an icon or relic to show the veneration of honor, in contrast with *latria*, the adoration of worship due to God alone. See Lily Ross Taylor, "The 'Proskynesis' and the Hellenistic Ruler Cult," *Journal of Hellenistic Studies* 47, Part 1 (1927): 53–62.

37. Mathews, *Byzantium*, 45; Kitzinger, "The Cult of Images in the Age before Iconoclasm," 94.

38. Kitzinger describes a *palladium* as a "public cult object recognized by all," which instills courage in those who use it and fear in the hearts of enemies ("The Cult of Images in the Age before Iconoclasm," 110). For the growing power and use of icons, see Noble, *Images, Iconoclasm, and the Carolingians*, 32–34; Kitzinger, "The Cult of Images in the Age before Iconoclasm," 110–12; Averil Cameron, "Elites and Icons in Late Sixth-Century Byzantium," *Past and Present* 84 (August 1979): 3–35; John McGuckin, "The Theology of Images and the Legitimation of Power in Eighth Century Byzantium," *St. Vladimir's Theological Quar-terly* 37, no. 1 (1993): 39–58; Antony Eastmond, "Between Icon and Idol: The Uncertainty of Imperial Images," in *Icon and Word: The Power of Images in Byzantium*, ed. Antony Eastmond and Liz James (Alder-shot, Hampshire, UK: Ashgate Publishing, 2003), 73–85.

## Iconoclasm

Such visible outpouring of honor, trust, and devotion, seemingly aimed at material objects and not merely the holy one depicted, sometimes slid into the realm of superstition and gave rise to charges of idolatry. Certainly something greater than superstition was at issue when the first major wave of iconoclasm hit in 726, with Emperor Leo III speaking against icons and removing the Christ icon over the Chalke ("bronze") Gate of his palace in Constantinople.[39] Monks and civil officials were killed for their protection of icons; monasteries were sacked. Churches and homes were stripped of icons and relics, and many icons were literally defaced if not completely destroyed. Syrian monk John of Damascus, writing from what ironically was now the safety of the Umayyad Empire, beyond Byzantine borders, responded immediately with a passionate defense of icons, which over the next fifteen years he developed in three treatises. Exploring the concepts of image, idols, and

---

39. Description and analysis of the iconoclastic controversies are vast. See Kitzinger, "The Cult of Images in the Age before Iconoclasm"; Noble, *Images, Iconoclasm, and the Carolingians*; McGuckin, "The Theology of Images and the Legitimation of Power in Eighth Century Byzantium"; Belting, *Likeness and Presence*, 144–63; Marino, *Storia della Legislazione sul Culto delle Imagini dall'inizio fino al trionfo dell'Ortodossia*; Alice-Mary Talbot, ed., *Byzantine Defenders of Images* (Washington, DC: Dumbarton Oaks, 1998); Moshe Barasch, *Icon: Studies in the History of an Idea* (New York: NYU Press, 1992). Andrew Louth's translation of St. John of Damascus, *Three Treatises on the Divine Images* (Crestwood, NY: St. Vladimir's Seminary Press, 2003), as well as his *St. John Damascene: Tradition and Originality in Byzantine Theology* (Oxford: Oxford University Press, 2002) are classics; Daniel Sahas, *Icon and Logos: Sources in Eighth-Century Iconoclasm* (Toronto: University of Toronto Press, 1985) provides an introduction and translation of related conciliar texts.

*Many icons and other religious images were defaced or destroyed during eighth- and ninth-century waves of iconoclasm.*

worship, he makes the primary argument that the incarnation made it permissible to create images of Christ and the saints. He contends that accusations of idolatry are rooted in a fear of matter, which God has made holy. Moreover, as God is Creator, and humans are in the image and likeness of God, so we ought to create images.

Church councils were called. The 754 Council of Hieria laid out the iconoclast position, arguing that icons separated Christ's human nature from his divinity; only the human could be depicted. Moreover, it sought to reinforce the sacrament of the Eucharist as the primary locus of worship. In 787, Empress Irene called the Second Council of Nicaea, which responded with the iconodule position that the honor given to the image passes on to its prototype; indeed, it was taught, holy images ought to be venerated with love wherever they were found:

> We preserve untouched the entirety of the Holy Tradition of the Church, whether expressed verbally or non-verbally. One of these traditions commands us to make pictorial

representations, in as much as this is in accordance with the history of the preaching of the Gospels, and serves as a confirmation that Christ in reality, and not as mere apparition, became man. . . . On this basis we define that the holy icons, in exactly the same way as the holy and life-giving Cross, should be presented (for veneration), . . . so long as the representations are done well; and they shall be shown in the holy churches of God, on sacred vessels and liturgical vestments, on walls, furnishings, and in houses and along the roads; and these icons will be of [Jesus, Mary, angels, and saints]. . . . [T]he more often these latter, the more often will those who lift up their eyes to them learn to commemorate and to love their prototype; and will be inspired to press their lips to their representations in veneration and honor [*dulia*] of them, but not in actual worship [*latria*] of them, which . . . is reserved only for him who is the subject of our faith and is proper for the divine nature.[40]

Armenian emperor Leo V revived iconoclastic policies in 813, meeting opposition in Abbot Theodore of Studios and Patriarch Nicephorus and gaining little popular support. An 815 council again proscribed images, but violence continued. Finally in March 843, with the Synod of Constanti-

40. From the "Definition of the Holy Great and Ecumenical Council, the Second in Nicaea," as quoted from Sergei Bulgakov, *The Icon and Its Veneration* [Ikona i ikonopochitanie] (Moscow, 1996), in Yazykova, *Hidden and Triumphant*, 18–19. For the complete "Definition," see Sahas, *Icon and Logos*, 177–81. Note also Yazykova, *Hidden and Triumphant*, 185n5, regarding *latria* and *dulia*: "In the discussion of icons, these Latin terms are paired together. . . . They are derived from Greek and are used to differentiate the difference between worship (given to God alone) and veneration (respect shown to the saints or an image)."

nople, Empress Theodora and Patriarch Methodios brought about the definitive restoration of icons, celebrating with a procession of icons to Hagia Sophia known as the "Triumph of Orthodoxy." The Orthodox Church continues to celebrate this moment as a yearly feast on the first Sunday of Great Lent. Clearly political and economic factors, as well as theological conflicts, contributed to the iconoclast controversies. Yet after 843, as Robin Cormack puts it, "The icon was not just a tolerated object; it was the sign and symbol of Orthodoxy, a distinguishing feature of the full, agreed dogma of the eastern church."[41]

## Icons in Liturgy and Life

After iconoclasm, use of icons became more central in the life and practice of the Eastern Church, especially as the Byzantine tradition spread to the newly formed states of eastern Europe, especially Russia. Indeed, icons came to be seen as "the acknowledged setting for any liturgical service."[42] Standards for painting became more defined as various schools of iconography came into their own,[43] and

41. Robin Cormack, *Painting the Soul: Icons, Death Masks, and Shrouds* (London: Reaktion Books, 1997), 46, as quoted in Noble, *Images, Iconoclasm, and the Carolingians*, 50.

42. Nancy Patterson Ševčenko, "Icons in the Liturgy," *Dumbarton Oaks Papers* 45 (1991): 45.

43. The high point of the Byzantine icon is generally acknowledged to be the thirteenth to fourteenth centuries during the Komnenos and Palaelogus dynasties. With the 1453 fall of Constantinople to the Turks, the tradition of icons continued elsewhere, as they were shared across cultures. Russian iconographers first studied under the Greeks, then developed their own styles and schools, including the Novgorod, Pskov, and Moscow Schools. See Yazykova, *Hidden and Triumphant*, 20–23.

iconographic images were incorporated into church archi-
tecture in new ways. Walls now were covered with mosaics
and frescoes as well as panel icons. The earlier practice of
putting panel icons on the chancel screen marking the
sanctuary space gradually gave way to a rule to do so and
thus led to the development of the iconostasis.[44] What
started as one row of icons soon grew to two, and by the
fifteenth century the structure included up to five rows of
icons, each representing a particular theme. By the six-
teenth century, small foldable iconostases existed that
could be used at home or when traveling.[45]

After iconoclasm, usage and devotion to icons needed
to appear more rationally justified; thus, conditions for the
veneration of images in churches were organized into a
programmatic framework that allowed the Church both
to guide and limit worship:

> [Icons] had a predetermined location in the churches and
> also were given a specified function in church ritual. The
> church thereby expected to direct the attention of the faith-
> ful first and foremost to official liturgy, which was the
> primary means of ecclesiastical self-representation. Image
> and liturgy related to each other in such a way that the
> liturgy contributed to the control of the image and pre-
> vented any paramagical excesses. . . . In this way the
> church gained control of a medium that once threatened
> its authority. An activity that had been carried on outside

44. On development and meaning of the iconostasis, see Belting,
*Likeness and Presence*, 233, 238; Lossky and Ouspensky, *The Meaning
of Icons*, 60–68; Quenot, *The Icon: Window on the Kingdom*, 47–63;
Mathews, *Byzantium*, 59–64; Christopher Walter, "The Origins of the
Iconostasis," *Eastern Churches Review* 3 (1971), reprinted in *Studies
in Byzantine Iconography* (London: Variorum Reprints, 1977), 251–67.
45. Lossky and Ouspensky, *The Meaning of Icons*, 60.

the official church was now incorporated within it, its features controlled by the church.[46]

Priests began to lead veneration of icons in liturgy using a particular order, and the liturgical calendar came to determine which icons of saints would be put on a stand[47] for *proskynesis* each day.[48] Yet many iconographic images within liturgical space are not directly involved in ritual action *per se*. Images on the walls and iconostasis tend to set the tone for the liturgy and "make the content of the liturgy visible and concrete."[49] Though icons are often incensed during liturgy, and the faithful regularly light candles before them in church, according to the liturgical calendar only two feasts actually include icons in the official rituals of the day: the Sunday of Orthodoxy, commemorating the end of iconoclasm, and the feast of Akathistos, commemorating the Constantinopolitan victory over the Avars with the assistance of the *Theotokos*.[50] Thus Nancy Patterson Ševčenko submits that any consideration of the use of icons needs to define liturgy in a wide sense to include not only what takes place in church but also interaction occurring in monastic cells, in the home, and even on the battlefield.[51] Icons often

---

46. Belting, *Likeness and Presence*, 172, 183.

47. The stand for an icon in the church is called a "proskynetarion" and is placed where the faithful can "greet the saint" on their entrance with a kiss, possibly a bow, a short prayer, and the sign of the cross, repeated up to three times in honor of the Trinity. See Quenot, *The Icon: Window on the Kingdom*, 46.

48. Belting, *Likeness and Presence*, 172, 229.

49. Ibid., 229.

50. Brubaker, "The Sacred Image," 10. It should be noted that many miracle working icons have their own feast days; some have more than one (communication with Marek Czarnecki).

51. Ševčenko, "Icons in the Liturgy," 45.

have been carried in processions—as early as the ninth century but definitely by the eleventh century; during the Byzantine era, confraternities dedicated to particular images would process their icons around the city weekly.[52] Military ceremonies have also used icons, and during battle campaigns it was not uncommon for the opposing side's icons to be taken captive as booty.[53] Pilgrimage to visit particular icons, especially to those known to be miracle working, has long been part of tradition as well.

Without a doubt, then, liturgy and shared devotion are integrated in Eastern Christianity; icons are present in both private and public spaces. In the home, most Eastern Christians have an icon corner where members of the family and guests alike may "greet" the saints in prayer. Devotion involving icons often starts at baptism, where an infant may receive an icon of the saint whose name he or she bears. Marriage includes a gift of icons from godparents and a blessing with icons by the fathers of the spouses, and icons also are part of funeral rituals.[54] Go to any Orthodox church with young families, and one likely will see mothers teaching babies how to kiss the saints depicted in the icons. Belting comments on how such devotion has served laypeople:

> Meditation in front of religious images was an activity that enabled lay people to play the role of saints and to live temporarily like a saint. The practice of image devotion involved the same images that had been used by the saints and had inspired their visions. By training their own imagination, urban people sporadically entered the saints'

52. Brubaker, "The Sacred Image," 10.
53. Ibid.
54. Quenot, *The Icon: Window on the Kingdom*, 43.

community, at least in the prescribed exercise of daily devotion in which images offered the first stimulus. Images helped overcome the limits of religious experience, which were imposed on the laity because of their secular life with its many practical needs.[55]

Perhaps more clearly in the East than in the West, mysticism is always the goal if not the rule, and prayerful devotion to saints already in heaven and yet still present in their icons is seen as a religious practice open to all.[56]

John of Damascus writes, "I saw the human face of God, and my soul was saved."[57] Fundamentally, to pray before the saints in the Eastern tradition, whether at home or in a more public space, is to encounter the saints before God and to join with them in prayer to God. Such prayer never can be fully regulated. As Sebastian Brock writes in his conclusion concerning the iconoclast controversy,

> I would like to suggest that the real but unvoiced issue underlying the whole iconoclast controversy has nothing at all to do with Christology, and very little (directly at least) with the legitimacy of images. It is rather a question of how far the divine is allowed to impinge on the human world.[58]

In the chapters that follow, we will explore how this "divine impinging via icons" happens in the West.

---

55. Belting, *Likeness and Presence*, 362.
56. Ibid., 410–11; Yazykova, *Hidden and Triumphant*, 55.
57. As quoted in Yazykova, *Hidden and Triumphant*, 5.
58. Sebastian Brock, "Iconoclasm and the Monophysites," in *Iconoclasm*, ed. Anthony Bryar and Judith Herrin (Birmingham, UK: Center for Byzantine Studies, University of Birmingham, 1977), 57, as quoted in McGuckin, "The Theology of Images and the Legitimation of Power in Eighth Century Byzantium," 48.

| Chapter 2 | Images and the Western Church |

To understand the possible meaning of icons for Roman Catholics today, it is necessary first to examine how icons were received by the Western Church in the medieval period and then to analyze how and why those images gave way to more traditionally "Western" devotional art. Like the East, the West has a long tradition of prayer with images, but this has taken different forms, responding to different pulses in society and the life of the Church. Moreover, as in the Eastern Church, the Roman Church has had its own strains of iconoclasm and imposition of regulations on sacred images.

### Artistic Exchange between the East and West

After the resolution of the iconoclastic controversies in the East, Byzantine iconography developed to a widely recognized level of technical perfection, and Eastern art was held in esteem across the Christian world. Icons were circulated as travelers passed through Constantinople and other major junction cities. Particularly in the eleventh and

twelfth centuries, icons were brought to the West as gifts
by royalty, dignitaries, ecclesiastics, scholars, artists, and
traders.[1] Western monasteries, including Cluny, Moissac,
and Grandmont, among others, also kept in regular contact
with monasteries of Byzantium and the Holy Land, facili-
tating exchange.[2] Sometimes icons were stolen; many were
looted from Constantinople when the city was sacked dur-
ing the Fourth Crusade in 1204.

   Western familiarity with icons also grew out of the migra-
tion of iconographers. Iconoclasm forced some to flee the
East, and in the tenth century, a number of Byzantines,
including monks of the Order of St. Basil, settled in the
southern end of the Italian peninsula.[3] By the twelfth cen-
tury, especially under the patronage of King Roger II (1095–
1154), his son William I (1120–1166), and grandson William
II (1154–1189), Byzantine artists were creating monumental
mosaics in the style of Eastern icons throughout Norman

   1. William D. Wixom, "Byzantine Art and the Latin West," in *The
Glory of Byzantium: Art and Culture of the Middle Byzantine Era A.D.
843–1261*, ed. Helen C. Evans and William D. Wixom (New York:
Harry N. Abrams, 1997), 435–36. See also Holger E. Klein, "Eastern
Objects and Western Desires: Relics and Reliquaries between Byz-
antium and the West," *Dumbarton Oaks Papers* 58 (2004): 283–314.
   2. Wixom, "Byzantine Art and the Latin West," 438, 441.
   3. Ibid., 436; Giovanna Paravicini, *Icone Russe della Collezione Orler
nel Monastero Greco di Grottaferrata* (Vicenza: Terra Ferma, 2004),
12–13: Regarding Byzantines in the West, the Greek monastery of
Grottaferrata, outside Rome, is of particular interest for its East–
West connections. Its roots trace to this era in Calabria, southern
Italy. In 1004, Abbot Nilus moved the community to Grottaferrata,
where they continue to celebrate the Greek rites using icons, united
with the Roman patriarch. For more on the icons of Grottaferrata,
see Maria Andaloro, "Polaritá byzantine, polaritá roman nelle pit-
ture di Grottaferrata," *Italian Church Decoration of the Middle Ages
and Early Renaissance* (Bologna: Nuova Alfa Editoriale, 1989), 13–26.

Sicily.[4] Venice also held allure for Eastern artists, as it had been a Byzantine province from the sixth century, before gaining its independence in the eleventh.[5] Especially after the 1204 Sack of Constantinople, many Greek artists settled in the Veneto region and other areas, including Crete and Corfu. The 1453 fall of Constantinople also triggered an exodus of Byzantines to the West; many again went to Venice, where Greek workshops had created beautiful iconographic mosaics in the basilica of San Marco just decades earlier.[6] Sharing the icon tradition also appears to have

4. Wixom, "Byzantine Art and the Latin West," 438.

5. Maria Georgopoulou, "Late Medieval Crete and Venice: An Appropriation of Byzantine Heritage," *The Art Bulletin* 77, no. 3 (September 1997): 479.

6. Wixom, "Byzantine Art and the Latin West," 438; M. Manoussacas and Ath. Paliouras, *Guide to the Museum of Icons and the Church of Saint George* (Venice: Aspioti-Elka, 1976), 11; Hans Bloemsma, "Venetian Crossroads: East and West and the Origins of Modernity in Twelfth-Century Mosaics in San Marco," *Journal of Intercultural Studies* 31, no. 3 (2010): 302. For more on Byzantine artists working in the West and their effect on Western artists, see James Stubblebine, "Byzantine Influence on Thirteenth-Century Italian Panel Painting," *Dumbarton Oaks Papers* 20 (1966): 85–101; Maria Pia di Dario Guida, *Icone di Calabria e Altre Icone Meridionali* (Messina: Rubbetino, 1992); Renato d'Antiga, *Guida all Venezia Bizantina* (Padova: Casadei Libri, 2005); Nancy Patterson Ševčenko, "The 'Vita' Icon and the Painter as Hagiographer," *Dumbarton Oaks Papers* 53 (1999): 149–65; Annemarie Weyl Carr, "Byzantines and Italians on Cyprus: Images from Art," *Dumbarton Oaks Papers* 49 (1995): 339–57; Amy Neff, "Byzantium Westernized, Byzantium Marginalized: Two Icons in the *Supplicationes Varie*," *Gesta* 38, no. 1 (1999): 81–102; Robert Nelson, "A Byzantine Painter in Trecento Genoa: The Last Judgment at San Lorenzo," *The Art Bulletin* 67, no. 4 (December 1985): 548–66; Hans Belting, *Likeness and Presence*, trans. Edmund Jephcott (Chicago: University of Chicago Press, 1994), 36–46; 184–207, 330–76; Belting, "The Invisible Icon and the Icon of the Invisible: Antonello

occurred as a result of Westerners going east. During the Crusades, some Western artists were recruited to work in reclaimed sites of the Holy Land, where they learned the Byzantine style of iconography.[7]

This exchange of art and artists ultimately led to a mixing of styles, which, while spreading the icon to the West, also brought "Westernizing influences" to icons in the East. Ultimately the exchange was to lead to the demise of the icon in the West as it gave way to Renaissance art and to the decline of iconographic standards in the East where artists began to incorporate Western elements fundamentally outside the canons for iconography. Called the *maniera greca*, the Westernized style of Byzantine iconography was

---

and New Paradigms in Renaissance Painting," in *Watching Art: Writings in Honor of James Beck*, ed. Lynn Catterson and Mark Zucker (Todi, Peruggia: Ediart, 2006), 73–83; Marina Falla Castelfranchi, "Disiecta membra. La pittura bizantina in Calabria (secoli IX–XII)," in *Italian Church Decoration of the Middle Ages and Early Renaissance*, ed. William Tronzo (Bologna: Nuova Alfa Editoriale, 1989), 81–100; Ernst Kitzinger, "Mosaic Decoration in Sicily under Roger II and the Classical Byzantine System of Church Decoration," *Church Decoration of the Middle Ages and Early Renaissance*, ed. William Tronzo (Bologna: Nuova Alfa Editoriale, 1989), 147–65; Maria Kazanaki-Lappa, *Arte Bizantina e Postbizantina a Venezia*, translated to Italian from Greek by Angeliki Tzavara (Villorba: Eurocrom, 2009); Thomas E. A. Dale, *Relics, Prayer, and Politics in Medieval Venetia: Romanesque Painting in the Crypt of Aquileia Cathedral* (Princeton, NJ: Princeton University Press, 1997), 21–34.

7. Jaroslav Folda, "Crusader Art," in *The Glory of Byzantium: Art and Culture of the Middle Byzantine Era A.D. 843–1261*, ed. Helen C. Evans and William D. Wixom (New York: Harry N. Abrams, 1997), 389, 392; Wixom, "Byzantine Art and the Latin West," 446–48, 486. See also Kurt Weitzmann, "Icon Painting in the Crusader Kingdom," *Dumbarton Oaks Papers* 20 (1966): 49–83; Ševčenko, "The 'Vita' Icon and the Painter as Hagiographer."

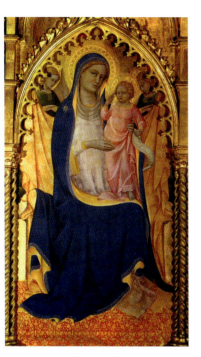

*In medieval Italian painting, small naturalistic details began to shift art from the symbolic language of icons toward the realism of Renaissance humanism. (Madonna, painted by Lorenzo Monaco, circa 1410.)*

widespread by the thirteenth century.[8] Initially, artists inserted small details from Western art into icons that did not alter their Orthodox characteristics.[9] Catholic patrons liked thematic details from late Gothic art, and thus artists experimented with elements from the two traditions, creating new compositions.[10] While first maintaining typical half-bust presentation of saints, the use of gold, and a sense of emotional reserve in their figures, iconographers began to introduce imaginative Western interpretations of Byzantine imagery. By the thirteenth century, the Italian penchant for a sense of communicability and visible warmth of emotion could be seen, with greater animation of subjects' eyes and mouths.[11] By the fourteenth century, backgrounds

8. Wixom, "Byzantine Art and the Latin West," 448, 486.

9. Kazanaki-Lappa, *Arte Bizantina e Postbizantina a Venezia*, 11.

10. Ibid., 11.

11. Hans Belting, "The Invisible Icon and the Icon of the Invisible," 83. Bloemsma also notes that Robin Cormack has suggested that perhaps such expressionist tendencies evolved in response to a diminished emotional response to icons: "As the experience of icons became continually more familiar, so the responses of viewers might have become jaded and have needed to be progressively refined

began to include reference to limited earthly space. Artists and patrons desired realistic humanism rather than reference to a theocentric eternal space. Hans Belting describes the tension:

> Icons were not just images like other images. They required worship [sic] and thus had to address the claim that they were justly qualified for veneration. It was not the visible record of our world but the epiphany of another, a transcendental world which they were meant to represent. Seen with Italian eyes . . . such icons turned into a major problem for Italian art. The Renaissance revision of the image demanded *radical visibility* resulting in the equation of the *visible* with the *real* in our gaze.[12]

The definitive blow for the icon came as Western artists, either not knowing or not valuing the theological grounding for using inverse perspective, gradually let it go for the more "ingenious" use of depth perspective, depicting the visibly observed world as the "real" world. Centuries later, icons went through a similar fate in eighteenth-century Russia, as Peter the Great turned to the West and imposed a more three-dimensional style that included modeling with light and shadow rather than having light emanate from within the one depicted and using lavish decoration rather than the traditional asceticism of the ancient icon.[13] In this way, art formerly considered icono-

---

with 'innovations.' " See Bloemsma, "Venetian Crossroads," 306, citing Cormack, *Painting the Soul*, 159–60.

12. Belting, "The Invisible Icon and the Icon of the Invisible," 73 (emphasis mine).

13. Irina Yazykova, *Hidden and Triumphant: The Underground Struggle to Save Russian Iconography*, trans. Paul Grenier (Brewster,

graphic no longer used the pure "grammar" or "language" of Orthodox icons. Some art historians and people of faith believe this was to affect the relationship between the viewer and the saint depicted. The viewer now could see either "devotional art" or just "art," which might arouse an emotional response and perhaps spiritual reflection but which did not necessarily demand the cult response of veneration due to icons.[14]

### Western Devotional Art

Whether evolved from icons or derived from native Western artistic tradition, authentic "devotional" art over time

---

MA: Paraclete Press, 2010), 39–41. By the nineteenth century, at least around the capital, neoclassical art replaced the icon in Russia. Mahmoud Zibawi, *Eastern Christian Worlds* (Collegeville, MN: Liturgical Press, 1995), 97–98: Eastern Catholic icons of the eighteenth century in Aleppo also shared a mixture of Byzantine and Western themes. "From one generation to the next, the icon, having lost its identity, turns to a new style of painting. The basic models are still recognizable, but the execution is awkward and unskilled. Falsely naïve, poorly Western, it is a heterogeneous mixture of local and foreign elements gathered into a hybrid interpretation. We have a folkloric pictorial tradition in which painters borrow equally from Byzantine art and Western painting styles, while lacking a thorough knowledge of the basic principles of either one."

14. See Bloemsma, "Venetian Crossroads," 310n6, for sources regarding the shift from "cult images" to Renaissance "art." Quoting Michael Cole in J. Elkins and R. Williams, *Renaissance Theory* (New York: Routledge, 2008), 217, Bloemsma notes that the dividing line between devotional art with cult value and Renaissance art may not be as hard and fast as Belting suggests: "It's not that we don't have a sense that something called 'art' is invented in the Renaissance. [. . .] What seems incorrect about Belting's account is the idea that at the moment of the Renaissance, artworks suddenly cease to have cult value."

has evoked its own kind of spiritual response. Usually created by either simplifying more involved narrative scenes or "humanizing" a hieratic image like an icon, the devotional image "needs to empty itself of other contexts, and requires a certain amount of dignity and visual center to encourage quiet contemplation."[15] Beyond painting or carved relief, devotional art in the West has taken various forms: the altarpiece, sculpture, or art print, as well as smaller objects like *jésueaux* (crafted Jesus dolls in artfully designed cribs), or crafted wax *ex votos* offered in thanks for miracles after requesting a saint's intercession. In contrast with icons, where canons of tradition typically define whether an image is a suitable medium for representing the presence of a holy person, for much of history in the West, defining a piece as devotional art in some ways has been more open and more determined by the human emotional response evoked by the piece.[16] Church authorities

---

15. Kristen Van Ausdall, "Communicating with the Host: Imagery and Eucharistic Contact in Late Medieval and Early Renaissance Italy," in *Push Me, Pull You: Imaginative and Emotional Interaction in Late Medieval and Renaissance Art*, ed. Sarah Blick and Laura Gelfand, 2 vols. (Boston: Brill, 2011), 1:467–69; Juan Luis Gonzalez Garcia, "Empathetic Image and Painted Dialogues: The Visual and Verbal Rhetoric of Royal Private Piety in Renaissance Spain," in Blick and Gelfand, *Push Me, Pull You*, 490.

16. Hetherington, introduction to *The Painter's Manual of Dionysius of Fourna*, i; Guida, *Icone di Calabria e Altre Icone Meridionali*, 22, my translation: "But especially in the West in the bilateral icon-person relationship, the second term plays a key role in the 'life' of the icon itself, to the point that certain classical characteristics of the icon, which ought to be achieved in a 'spiritual' way, are lost, and even sculptures can be the subject of popular piety. Indeed, in the process so evolved, sculptures in the round, even if condemned by theology and excluded from the Byzantine liturgy, now entered the field,

on occasion have legislated on public images in the West, but for the most part, at a private level, if an artistic work supports prayer and intimacy with God, people simply use it. Such piety involves the senses and could include offering flowers or lighting candles before the one depicted, touching, holding, or embracing a statue, or placing an artistic object in a special place, such as at the tomb of a saint or underneath the altar during Mass.[17]

### The Indulgenced Image

One common Western devotion through the medieval and baroque periods was to pray before an "indulgenced image." The origins of this practice appear to trace to the time of Pope Innocent III (1198–1216), who attached an indulgence to a prayer he wrote in honor of the *Vera Icona*, the image of the Holy Face of Jesus represented on Veronica's veil.[18] By praying the prayer before the image, one

---

returning as a product peacefully reborn in the West as a typical Western component in the story of the passage from the Eastern icon to the Western devotional image." ("Ma è sopratutto in Occidente che nel rapporto bilaterale icona-popolo il secondo termine gioca un ruolo determinante per la "vita" stessa dell'icona; al punto che certi connotati classici dell'icona, come quello che debbe essere realizzata in una materia "spirituale," si perdono, e oggetto della pietà popolare possono essere perfino le sculture. Anzi nel processo così evolutosi entrano ora in campo anche le sculture a tutto tondo che condannate dalla teologia ed escluse dalla liturgia bizantina tornano come un prodotto rinato in Occidente in serendosi come una componente tipicamente occidentale nella vicenda del passagio dall'icona orientale all'immagine di devozione occidentale.")

17. Sarah Blick and Laura D. Gelfand, introduction to Blick and Gelfand, *Push Me, Pull You*, xl–xli.

18. For more on indulgenced images, see Henk van Os, *The Art of Devotion* (Princeton, NJ: Princeton University Press, 1994), 82; Sixten

could receive a small indulgence. Driven by fear of the afterlife, with people not actually knowing the worth of indulgences in the scope of eternity, the practice spread to include prayer with altarpieces, art prints, reliefs, and other religious images that could be either publically displayed in a church or purchased and used for private devotion at home.[19] The indulgenced altarpiece usually was the largest of this sort of image, advertising publically by both its imagery and an inscription the terms and privileges of the indulgences to be gained from praying before it, which might vary depending on the feast day.[20] As laypeople sought opportunities to earn indulgences, churches also petitioned for privileges to attach indulgences to images in their spaces, as often the terms of an indulgence would include making a charitable donation to a particular church's building campaign. Ultimately, the authority to sanction such a practice rested with the pope, who could

---

Ringbom, *Icon to Narrative: The Rise of the Dramatic Close-up in Fifteenth-Century Devotional Painting* (Doornspijk, Netherlands: Davaco, 1983), 23–30; and the following essays in Blick and Gelfand, *Push Me, Pull You*: Amy M. Morris, "Art and Advertising: Late Medieval Altarpieces in Germany," 1:325–45; Walter Gibson, "Prayers and Promises: The Interactive Indulgence Print," 1:277–324; Susan Liebacher Ward, "Who Sees Christ? An Alabaster Panel of the Mass of St. Gregory," 1:347–81.

19. Gibson, "Prayers and Promises," 1:322–23. See also Van Os, *The Art of Devotion*, 82–83. When we reflect on the so-called sale of indulgences, most people reference the overquantified aspect of charitable giving often stipulated as a condition for earning an indulgence. Yet in another context, many indulgences were "bought" or "sold" in the simple sense of acquiring or disseminating the art prints providing the required prayers. Whether indulgence itself actually was "earned" was dependent on whether the conditions for it were fulfilled; an exchange of money was not necessarily a prerequisite for gaining an indulgence.

20. Morris, "Art and Advertising," 1:325, 327, 341.

delegate such powers to the local bishop.[21] Few indulgenced altar panels still exist today, as they particularly were sought out for destruction during the Reformation.

One of the most popular indulgenced images of the medieval and Renaissance period was the *Mass of St. Gregory*. The imagery is derived from a legend that during a Mass celebrated by Gregory the Great (540–604), a congregant voiced doubts about the true presence of Christ in the Eucharist. In answer to Gregory's prayers for some answer from heaven, a vision of Christ as the Man of Sorrows appeared on the altar. The legend eventually was associated with an Italo-Byzantine *Vera Icona* image preserved at Santa Croce in Rome, traditionally understood to have been commissioned by Gregory to commemorate the event.[22] Though initially connected with issues of belief about the eucharistic presence of Christ, in time, the *Mass of St. Gregory* image became more connected with praying for the dead and remittance of purgatorial punishment, due mostly to the legendary efficacy of Gregory's own prayers

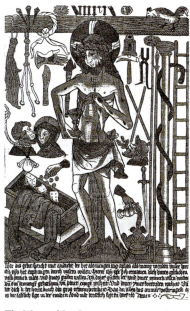

*The* Mass of St. Gregory *was a popular indulgenced image during medieval times. The prayers to be said are printed below the image.*

---

21. Ibid., 335, 342.

22. Gibson, "Prayers and Promises," 1:296; Van Os, *The Art of Devotion*, 106–13.

for the dead. Consequently, the practice of praying before images of the *Mass of St. Gregory* became a popular devotion concerned with indulgences, and particularly through the fifteenth century, this image often included visual references to purgatory.[23] Inexpensive prints of the image, with the prayers printed below it, were obtained easily throughout Europe, as well as more expensive carved wood or alabaster panels.[24] It also appeared on tomb monuments as a reminder to pray for the dead.[25]

### Remembering Death:
### Memento Mori *Images*

By the sixteenth century, partly as a Catholic response to Protestant refusal to pray for the dead, another form of devotional art became popular, the *memento mori*.[26] These macabre images of death could range from ivory carved corpses to art prints of lovely women, with flaps for skirts that could be lifted to reveal the sickening spiritual result of lust indulged. Small boxwood coffins opened to reveal worms amid a decaying body and the Last Judgment depicted on the doors of the lid. In Nuremberg, a statue created around 1310 called *Fürst der Welt*, "Prince of the World," depicts from the front a sweet-faced young boy, yet when one walks around to see the back of the statue, one finds an exposed decaying corpse.[27] Such images stand in sharp contrast with Eastern icons, where death generally

23. Gibson, "Prayers and Promises," 298–99.

24. Ward, "Who Sees Christ?," 347, 354, 375–76.

25. Gibson, "Prayers and Promises," 299.

26. Suzanne Karr Schmidt, "Memento Mori: The Deadly Art of Interaction," in Blick and Gelfand, *Push Me, Pull You*, 2:271.

27. Ibid., 261–63.

*Fürst der Welt, "Prince of the World" (circa 1310), served to remind the faithful that the sweetness of life is passing and that Christians ought to be well prepared for death.*

is not seen other than at Christ's resurrection victory as he harrows hell and brings Old Testament figures with him up to heaven. These are shocking images, fearful reminders of mortality in an era ravaged by the plague.[28] Yet they also spoke to people of the importance of living well, and being prepared for a good death: "Thus a coffin could be carried or worn as a symbol of hope rather than of despair, and the more detailed the handheld corpse, the better ingrained the viewer's meditations."[29] Art thus aided memory.

### Sacred Portraits and Meditation

The Eastern tradition of simply exchanging gazes with the one depicted also occurs in the West, with a parallel sense of "being seen" by the subject.[30] Where the icon had become viewed as "impenetrable" by some, the Western devotional image, with its usually more expressive emotionalism, "allowed the observer to identify themselves with what appeared, and to feel absorbed in its pictorial

28. Ibid., 270.
29. Ibid., 270, 293.
30. Blick and Gelfand, introduction to *Push Me, Pull You*, xlv; Garcia, "Empathetic Image and Painted Dialogues," 492.

world."[31] In some ways, Western devotional art functioned as icons did in the East. As an aid to contemplation, the sacred portrait was a kataphatic beginning aimed toward apophatic prayer:

> Art was considered the first step on the ladder to devotion, and mystical guides recommended that the devotee begin with an actual image, then produce an inner image, and then exclude all visual imagery to contemplate the formless God within the soul, attaining a mystical union.[32]

The goal was to stimulate piety, an emotional experience of contemplative immersion.[33] Moreover, as with the *memento mori*, meditation on the image was a mnemonic act to help fix both the figure and the mind-set in one's memory.[34]

Through the medieval and Renaissance periods, the use of devotional images was viewed as a way of making one's prayers more efficacious.[35] Like their Orthodox counterparts, Roman Catholics prayed with images as they asked particular saints to intercede for them. St. Anne, for ex-

31. Garcia, "Empathetic Image and Painted Dialogues," 490. Regarding emotional immediacy in images, changes within the Byzantine style itself had already brought a greater emotionalism to the icon by the thirteenth century. See Wixom, "Byzantine Art and the Latin West," 486; Guida, *Icone di Calabria e Altre Icone Meridionali*, 22.

32. Blick and Gelfand, introduction to *Push Me, Pull You*, xlvii. See also Garcia, "Empathetic Image and Painted Dialogues," 499.

33. Mark Trowbridge, "Sin and Redemption in Late-Medieval Art and Theater: The Magdalen as Role Model in Hugo van der Goes's Vienna Diptych," in Blick and Gelfand, *Push Me, Pull You*, 1:445. See also David Freedberg, *The Power of Images: Studies in the History and Theory of Response* (Chicago: University of Chicago Press, 1989), 161–91.

34. Garcia, "Empathetic Image and Painted Dialogues," 492, 505.

35. Blick and Gelfand, introduction to *Push Me, Pull You*, xlvii.

ample, popular in the fifteenth century, was often petitioned regarding marriage, conception, and safe childbirth. Sacred portraits also provided models for prayerful behavior. In some artworks, patrons might be depicted kneeling to the side of the main subject, praying a rosary.[36] In images connected with the passion, Mary Magdalene's grief-stricken way of viewing Christ's body modeled the heartfelt devotion to be evoked in the viewer. Tears in the subject likewise stirred compunction in the one praying.[37] In these and other ways, devotional art was a basic aid to prayer.

### *Miracles, Relics, and* Ex Voto *Offerings*

As with Eastern icons, some Western devotional art has been associated with miracles.[38] Traditionally miracles are associated more with prayer at the site of saints' relics or the place of a Marian apparition than with images. Certainly as the cult of images was developing in the East in the sixth century, relics were fulfilling a similar function in the West. Icons and relics both were expected to be efficacious in response to petition, both were circulated similarly as gifts, as purchases, or by theft, and both apparently had ways of asking to be returned to an original owner or

36. Ibid., 304–6; Morris, "Art and Advertising," 1:342; Van Os, *The Art of Devotion*, 80–81.

37. Trowbridge, "Sin and Redemption in Late-Medieval Art and Theater," 1:435–36; Garcia, "Empathetic Image and Painted Dialogues," 1:502.

38. Freedberg, *The Power of Images*, 284–85, 299–314; Richard Kieckhefer, "Holiness and the Culture of Devotion: Remarks on Some Late Medieval Male Saints," in *Images of Sainthood in Medieval Europe*, ed. Renate Blumenfeld-Kosinski and Timea Szell (Ithaca, NY: Cornell University Press, 1991), 298–99.

moved to another location.[39] Yet with the eleventh-century rise of lay spirituality and devotion to sacred images, in the West stories came to abound of statues that cried tears or bled, paintings that came to life to speak, touch, or strike viewers, and images that answered prayers for miraculous healings.[40] Marian images, in particular, seem to have become connected with miracles. Because Mary was assumed into heaven, believers had no body or tomb at which to pray and few second-class relics of her considered holiest of all women. Images thus became the locus of the sacred, and with the rise of the Marian cult, more miracles came to be associated with her image, including both paintings and sculptures.[41] In medieval times, ritual exorcisms became common in front of holy images at Marian shrines.[42]

That miracles occurred and prayers were answered is confirmed by the great flourishing of *ex voto* offerings at the tombs and shrines of saints. The "physical embodiment of devotional promises," *ex votos* could include "images of the devotee, candles, objects that no longer tormented their owners (worms, cherry pits), and objects no longer needed, such as crutches and shackles."[43] Created of wax, metals, or jewels, *ex voto* offerings were their own form of devotional art. At tombs or shrines where many miracles had occurred

39. Brubaker, "The Sacred Image," 11–12. Regarding images and relics, see also Belting, *Likeness and Presence*, 297–310.

40. Brubaker, "The Sacred Image," 11, 13.

41. Fredrika H. Jacobs, "Images, Efficacy, and Ritual in the Renaissance: Burning the Devil and Dusting the Madonna," in Blick and Gelfand, *Push Me, Pull You*, 2:152–55.

42. Ibid., 106.

43. Sarah Blick, "Votives, Images, Interaction and Pilgrimage to the Tomb and Shrine of St. Thomas Becket, Canterbury Cathedral," in Blick and Gelfand, *Push Me, Pull You*, 2:21, 24.

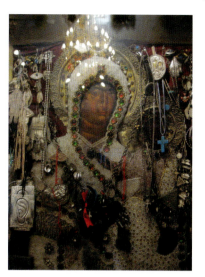

*This Marian icon is surrounded by* ex voto *offerings brought by the faithful in thanksgiving for prayers answered. (Chapel of St. James in the Church of the Holy Sepulchre, Jerusalem.)*

or prayers been answered, *ex votos* could pile up; occasionally they were counted and noted as part of promoting a holy person for canonization.[44]

### Images and Access to the Sacred

Fundamentally, the use of devotional art appears to be connected with issues of access to the sacred. Images are more easily produced than relics, and historically, images have risen in importance in the absence of other ways to contact a sensate holy reality. We can see this trend not only in the rise of miraculous images connected with Mary but also in the traditional practice of pilgrims to Santiago de Compostela, who to this day, on arrival at the cathedral, climb steps behind the altar and embrace a polychrome statue of St. James. Until the twelfth century, pilgrims were able to venerate the body of St. James at his tomb; yet from sometime before 1150 until 1879, the crypt was closed, and his relics were hidden from pilgrims.[45] This inability to "kiss the sepulcher" on arrival was a cause of great distress

---

44. Ibid., 31.

45. Kathleen Ashley, "Hugging the Saint: Improvising Ritual on the Pilgrimage to Santiago de Compostela," in Blick and Gelfand, *Push Me, Pull You*, 2:16–17.

and so gave rise to various practices of interaction with the statue of St. James.[46] The present statue, replacing an earlier one in 1665, holds a staff and a phylactery in his hand reading "*Hic est corpus Divi Iacobi Apostoli ac hispaniarum Patroni*," "This is the body of James, Holy Apostle and also Patron of Spain."[47] Though not a reliquary in itself, the statue in a sense took the place of the missing body of the saint. Indeed, the pilgrim Laffi, who went to Compostela in 1666, 1670, and 1673, wrote of embracing the statue: "If you kiss it reverently you will be granted plenary indulgence, though you are not allowed to touch the sacred body itself."[48]

At a broader level, Western eucharistic images of Christ played a similar role. In 1215, the Fourth Lateran Council mandated that the faithful were to receive the Eucharist at least once a year. Practices varied, but between the thirteenth and fifteenth centuries, communion generally was infrequent.[49] Kristen Van Ausdell notes that when physical ingestion of Eucharist was rare, "ocular communion" and then art became ways to "target and guide the desire to see and fully connect with the Eucharistic Christ."[50] To

46. Ibid.

47. Ibid., 17–18.

48. Ibid., 19.

49. Van Ausdall, "Communicating with the Host," 1:449n4; 450n8, quoting Caroline Bynum, *Wonderful Blood: Theology and Practice in Late Medieval Northern Germany and Beyond* (Philadelphia, PA: University of Pennsylvania Press, 2007), 87: "The faithful were urged to encounter with eyes where encounter with lips was dangerous and rare, to 'eat' by 'seeing.'" Bynum also notes that theologians occasionally would advocate using a veil to prevent even seeing the Eucharist, citing the need for faith without seeing evidence.

50. Van Ausdall, "Communicating with the Host," 1:449.

adore Christ in the Eucharist at Mass was to see him and love him, particularly at the raising of the Host during the consecration. Yet choir screens made getting a good view of the altar difficult.[51] Seeing the eucharistic Christ in adoration outside of Mass in a monstrance was one solution, but this was not always available: "Constant display was felt to devalue the Host and put it at risk of desecration or degradation. Moreover, a monstrance is relatively small, and . . . it takes considerable imagination to visualize the humanity of Christ when confronted with the abstraction of a Host wafer in such a vessel."[52] Thus through the twelfth and thirteenth centuries rose the popularity of painted crucifixes that focused on the Body of Christ and enabled visualization of the abstract concept of Christ's presence. Coinciding with the wave of Byzantine art and iconography coming through Italy, the first painted crucifixes bear a strong resemblance to Eastern icons, and Christ is depicted as being alive even in his death.[53] When the Host was elevated, it now appeared against the painted image of Christ hung behind the altar: "This intentional correlation between the Host and the crucified Christ conditioned the devout to 'see' the Host as the human God, but clearly emphasized his divine triumph over death."[54] New mendicant orders devoted to the passion and suffering of Jesus especially promoted use of such crucifixes, which in time came to reflect more on the death of Christ than his living.[55]

51. Ibid., 450.
52. Ibid., 451–52.
53. Ibid., 458–59.
54. Ibid., 459.
55. Ibid., 463–64.

### Western Regulation of Images

As a paraliturgical popular practice, praying with devotional images did not always get much focused attention from the magisterium of the Roman Church. Certainly at a local level, from early times bishops and pastors expressed either support or dislike for the practice. As in the East, Christian images were to be praised for their didactic purpose of educating the illiterate in the faith. Drawing from earlier sources, and heavily quoted in later times, Gregory the Great wrote in two letters of 599 and 600: "To adore images is one thing: to teach with their help what should be adored is another. What Scripture is to the educated, images are to the ignorant, who see through them what they must accept; they read in them what they cannot read in books."[56] Bishop William Durandus (1237–1296) expressed respect for images' ability to move the mind, sometimes even more than Scripture, saying, "In church we do not show as much reverence for books as we do for images and pictures."[57] Savonarolla (1452–1498) believed private devotional images should be small and inexpensive so that they could be used to inspire meditation.[58] Yet a distrust in the common people's ability to discern the truth in images is also a recurring theme. Bishop Theodulf of Orleans (c. 750/60–821), advisor to Charlemagne, wrote that a picture ought to foster truth, but that "pictures shaped by the art of artists always lead those who glorify them into error. . . . [I]t is certain that

---

56. As quoted in Brubaker, "The Sacred Image," 14.
57. Blick and Gelfand, introduction to *Push Me, Pull You*, xliv.
58. Ibid., xlvi.

they are the invention of artists and not the truth."[59] Writing around 835, Rabanus Maurus (780–856) advocates the use of writing over art, saying that writing "reveals truth" while the picture "sates the sight while it is still new but it palls once it is old, quickly loses its truth, and does not arouse faith."[60] Bernard of Clairvaux (1090–1153) likewise was suspicious of images, believing one should be able to "raise [oneself] above the phantasms of corporeal likeness rushing in from every direction."[61]

Until recently, most scholarship has posited that aside from having guidebooks for technique, Western European artists of the Middle Ages had little official legislation regarding creation of devotional art. Thomas Noble's 2009 analysis of the eighth-century Frankish response to Byzantine iconoclasm and the 787 acts of Nicaea II, however, has added much more nuance to our understanding of images in the Carolingian dynasty. Through most of the eighth century, the Western view was that images could be helpful to faith and that the honor given them is passed on to the person represented; images may be venerated.[62] In 794, however, the Carolingian court published the *Opus Caroli regis contra synodum*, a treatise concerned with tradition, order, and worship, including images. Opposed both to destruction of images and to their worship, the *Opus* says images are to be used for "decoration and

---

59. Brubaker, "The Sacred Image," 14. For a masterful treatment of Theodulf and Carolingian iconoclastic debate, see Thomas F. X. Noble, *Images, Iconoclasm, and the Carolingians* (Philadelphia, PA: University of Pennsylvania Press, 2009).

60. As quoted in Brubaker, "The Sacred Image," 15.

61. Blick and Gelfand, introduction to *Push Me, Pull You*, xlvi.

62. Noble, *Images, Iconoclasm, and the Carolingians*, 156.

commemoration."[63] It is unclear just how widely this decree was propagated or observed.

What is apparent is that by the time of the Council of Trent (1545–1563), the Church was concerned to address both superstition involving images and Protestant iconoclasm, and it made specific, clear decrees in regard to art.[64] Reaffirming Aquinas's teaching that "worship performed in the wrong manner or directed at the wrong subject constituted an error of faith," decrees mandated that "all superstition be removed from the use of sacred images."[65] Clergy were to remind parishioners that to kiss or to go down on one's knees before an image is out of honor for the one represented and not for the representation itself.[66] Moreover, "No one is to 'ask' something of or 'expect' anything from an image 'as was done by the pagans of old.' Placing 'confidence' of any sort in a material object was emphatically prohibited."[67] While the decrees actually

63. Ibid., 207.

64. Hetherington, introduction to *The Painter's Manual of Dionysius of Fourna*, i; R. Kevin Seasoltz, *A Sense of the Sacred* (New York: Continuum, 2005), 169.

65. Jacobs, "Images, Efficacy and Ritual in the Renaissance," 147.

66. Ibid. This is a simple reaffirmation of Nicaea II and St. Basil that "the honor shown to the image is transferred to the prototype, and whoever honors the image honors the person represented."

67. Jacobs, "Images, Efficacy and Ritual in the Renaissance," 148. According to Theodore Alois Buckley, *The Canons and Decrees of the Council of Trent* (London: Routledge, 1851), 214–15, Session 25 affirmed that it is good to invoke saints and to venerate their relics and to retain images of Mary and the saints with honor and veneration; but it condemned "wantonness" in images. New or "unusual" images need to be approved by a bishop, and "no images conducive to false doctrine . . . [are] to be set up."

are a reaffirmation of the ancient Church teaching direct-
ing devotion to God and the saints themselves and not
merely to the physical representations of them, they also
signify that excessive private devotionalism had become
out of control. Behavior toward a physical piece of art or
even a relic is one thing; one's spiritual intent or under-
standing of *who* is the object of such devotion is another.

This Western ambivalence toward devotion shown to
images continues to affect the Roman Church today. At what
point is image devotion superstitious? With a renewed focus
on the liturgy itself, what role does personal prayer have?
If images are oriented toward a private kind of prayer, what
ought to be the place of both public and devotional images
in churches? The Council of Trent encouraged the use of
images that could promote faith in truth and condemned
"images conducive to false doctrine."[68] This raises questions
regarding characteristics of a sacred image in the modern
era. In the East, canons for icons are seen as protectors of
doctrine; "non-canonical" icons are seen as possibly leading
people astray. Are particular guidelines needed in the
Roman Church, at least pertaining to icons if not to other
devotional art? To these questions we now turn.

68. Buckley, *Canons and Decrees of the Council of Trent*, 214.

## *Chapter 3*

# Vatican II's "Noble Simplicity"

*Icons, Images, and the Roman Church Today*

In the decades surrounding the Second Vatican Council, church art and architecture went through waves of change. Years of increased embellishment in church décor had left many in confusion as to the place of *devotional art*, meant for private prayer, and *liturgical art*, art within the church imaging aspects of the liturgy itself. A kind of iconoclasm commenced. Much devotional art was removed as many churches were stripped of all ornamentation to make room for the Vatican II ideal of "noble simplicity" recommended for both liturgical action and the accoutrements associated with it.[1] In addition, after years of resistance, the Church came to admit modern art to liturgical space.

---

1. Vatican Council II, *Sacrosanctum Concilium* (Constitution on the Sacred Liturgy), in *Vatican Council II: The Conciliar and Postconciliar Documents*, trans. Austin Flannery, rev. ed. (Collegeville, MN: Liturgical Press, 2014), no. 34: "The rites should be distinguished by

Yet the changes were not without conflict. Educated Catholics were glad to be rid of some low-quality art, but many churchgoers mourned the loss of images that accompanied such simplification. They grieved for the beloved recognizable faces of sanctity that had been part of their worship experience. While the ultimate goal was to refocus attention on the liturgy and the worshiping community itself, the starkness that replaced much church art left many worshipers cold, without adequate art for the personal devotion preparing one for liturgy or the ability to image the greater significance of the events occurring during liturgy.

In the years since Vatican II, the Church has moderated some of the more extreme aspects of "simplicity" and given more attention to identifying what is "noble" and fitting for worship.[2] Throughout this period, the Church has probed the delicate balance to be struck between artistic freedom

a noble simplicity"; no. 124: "Ordinaries are to take care that in encouraging and favoring truly sacred art, they should seek for noble beauty rather than sumptuous display." (Hereafter, unless otherwise indicated, all citations from the Vatican II documents are from the Flannery translation.); United States Conference of Catholic Bishops, *General Instruction of the Roman Missal* (hereafter GIRM) (Totowa, NJ: Catholic Book Publishing Corp., 2011), no. 292: "The ornamentation of a church should contribute toward its noble simplicity rather than to ostentation. Moreover, in the choice of elements attention should be paid to authenticity and there should be the intention of fostering the instruction of the faithful and the dignity of the entire sacred place."

2. Regarding the balance of values to be held in tension in church art and architecture since the liturgical reforms, see Michael E. DeSanctis, *Building from Belief: Advance, Retreat, and Compromise in the Remaking of Catholic Church Architecture* (Collegeville, MN: Liturgical Press, 2002).

of expression and the right of ecclesiastical authorities to prescribe what is appropriate. Almost echoing some of their Eastern counterparts, more recent Catholic guidelines have stated that creating sacred art for the church is a ministry, providing an integral aspect of worship. Moreover, while the Church does not give preference to one style of art, icons have been specifically named as having particular dignity and a firm place in the Roman Church.

## Catholicism and "Bad Art"

In the years following the Council of Trent, the Church codified liturgy and catechesis into fairly stable forms. Yet, especially with the rise of the Industrial Revolution, worshipers desired their churches to be colorful, lively places, a respite from the drear of urban life.[3] Modernity brought its traumas, and for several centuries the Catholic Church was not ready to engage with it. Many sought a return to an ethos of the medieval period, reflecting a more predominantly "Christian world." As a symbol of that time, the neo-Gothic style became popular in worship spaces.[4] Additional embellishments were added, and Baroque and Rococo elements multiplied. Combined with a liturgy conducted in Latin rather than the local vernacular, this kind of space meant the common people could become distracted or distanced from the communal heart of the eucharistic liturgical action, with private and public spheres of worship becoming almost indistinguishable.

---

3. Christopher Irvine and Anne Dawtry, *Art and Worship* (Collegeville, MN: Liturgical Press, 2002), 29.

4. R. Kevin Seasoltz, *A Sense of the Sacred* (New York: Continuum, 2005), 41.

In such a world, mass-produced "kitsch" religious art flourished, starting possibly in the mid-nineteenth century but proliferating particularly through the 1930s.[5] Usually identified with overly sentimental religious painting or statuary, kitsch, according to one dictionary definition, refers to anything that is "shoddy, trash, tripe, slush, cheap sentimentality, hokum, sob-stuff."[6] Moral theologian Richard Egenter says kitsch is "a work which in some way claims to belong to the realm of art but in some respect remains inadequate."[7] It can be present either in the work of art or in a response to it. Thus it is possible to respond to kitsch in kind with a less than truly religious

5. Colleen McDannell, *Material Christianity* (New Haven, CT: Yale University Press, 1995), 164.

6. Richard Egenter, *The Desecration of Christ*, trans. Edward Quinn, ed. Nicolette Gray (Chicago: Franciscan Herald Press, 1967), 14. See also Sally M. Promey, "Interchangeable Art: Warner Sallman and the Critics of Mass Culture," in *Icons of American Protestantism: The Art of Warner Sallman*, ed. David Morgan (New Haven, CT: Yale University Press, 1996), 155–57.

7. Egenter, *The Desecration of Christ*, 15. In religious art, kitsch can be the result of various possibilities: portraying a subject with sweetness and idealism that does not reflect the challenge of reality, giving a religious title to an image that is nonreligious by nature, trying to evoke a religious response by appealing to a lower level of emotionality, or gaining attention by using drama or eroticism rather than true perspective. While some mass-produced artwork may be made in good faith in the service of true devotion, kitsch is marked by some sort of deceit or a lack of sincerity. For example, images of saints that make them appear sexless, clothed in effortless sanctity, fail to convey the true person and the courage required for heroic virtue; saccharine-sweet angels do not reflect the frightening aspect of their presence described in the Bible; depicting Mary using a model who could be a pinup girl fails to reflect the full truth and beauty of who she is understood to be.

response. But it also is possible to have a genuine religious experience from kitsch work if it evokes a strong reaction to the truth of its recognizable subject while bypassing its worthless aspects.[8]

If the latter response explains the grief of those who lost beloved imagery during the years surrounding Vatican II, the former was what reformers aimed to address. To believe half-truths perpetuated by kitsch is to be stunted spiritually. Thus in 1933, German critic Hermann Broch could say that "Kitsch is the element of evil in the value system of art," and in 1959 Egenter could write: "In the light of Christian ethics art is not an ornamental addition to human life but an essential. A right relation to art is, therefore, one of those moral requirements with which the moral theologian and the priest must concern themselves."[9] Both thus affirmed those who would clear out rubbish, educate people on the spiritual harm of untruthful art, and promote a new popular art.

Art may be considered kitsch if some element of it is untruthful. This painting depicts a statue of the Blessed Mother as if it were the statue rather than the woman herself that should evoke awe in the viewer.

8. Ibid., 55, 113–14.

9. Quoted in McDannell, *Material Christianity*, 166; Egenter, *The Desecration of Christ*, 129.

## Raising the Standards: The Liturgical Movement

In the early twentieth century, the liturgical movement took on the challenge of renewing the liturgy. Figures like Virgil Michel, H. A. Reinhold, Maurice Lavanoux, John La Farge, Eric Gill, and others aimed to bridge the gap between the antimodernist Church and the art world while restoring active liturgical participation to congregants.[10] Greatly contributing to this work was the Liturgical Arts Society, founded in 1928 to "devise ways and means for improving the standards of taste, craftsmanship, and liturgical correctness in the practice of Catholic art in the United States."[11] In 1931, they published *Liturgical Arts*, a quarterly magazine aimed at US artists and architects edited for many years by Lavanoux. Here ideas were exchanged that aimed to battle against

---

10. On ecclesial art and the liturgical movement, see Keith Pecklers, *The Unread Vision: The Liturgical Movement in the United States of America: 1926–1955* (Collegeville, MN: Liturgical Press, 1998), 213–80; Susan J. White, *Art, Architecture, and Liturgical Reform: The Liturgical Arts Society (1928–1972)* (New York: Pueblo Publishing, 1990); R. Kevin Seasoltz, *The New Liturgy: A Documentation 1903–1965* (New York: Herder and Herder, 1966); Irvine and Dawtry, *Art and Worship*, 33–38.

11. White, *Art, Architecture, and Liturgical Reform*, viii, 70. Among their other activities, the Liturgical Arts Society ran a craftsmen's service to connect ecclesial customers with quality craftsmen, a building and information service to provide necessary information for Catholic building projects, and several exhibitions and competitions to cultivate and showcase new religious art. The Liturgical Arts Society was to influence Vatican II more particularly when friend of the society Monsignor Joachim Nabuco of Rio de Janiero was appointed moderator of the subcommittee on sacred art for the liturgy commission, and Lavanoux supplied materials and became a "technical advisor."

prison stone churches looking like jails on the outside and either wedding cakes or vaudeville theaters on the inside . . . cardboard chasubles and lace curtain albs and surplices, against gold fringe frontlets and female angels in pink and blue dance frocks, against fret-saw shrines and confessionals, against factory statues in "natural" colors tattooed with gold-leaf "decoration" on religious habits, against wood painted to imitate grained marble, against any and every sort of imitation.[12]

Liturgical Arts Society founding member Idesbald van der Gracht suggested that in the United States, the problem was related to Protestant suspicion of Catholic immigrants who arrived relatively late on the scene and were poor; the cheap church décor preferred by poor immigrant priests only reinforced stereotypes about Catholics having fewer cultural values. Yet now that Catholics had risen in status and education, they were ready to lead and reinspire quality art in the Church.[13]

One of the major tasks of the liturgical movement was to define "liturgical art" and its place in the Church in contrast with religious art more generally. Eric Gill and Jacques Maritain helped articulate some differences. Art to be used in the church, with the transcendent power to evangelize, was "sacred art," while art with a religious theme but not belonging in a worship space was simply "religious art."[14]

12. Benjamin Musser, "Letter to the Editor," *Liturgical Arts* 1, no. 2 (Winter 1932): 78, as quoted in White, *Art, Architecture, and Liturgical Reform*, 3.

13. White, *Art, Architecture, and Liturgical Reform*, 4–5; Pecklers, *The Unread Vision*, 234.

14. Pecklers, *The Unread Vision*, 218; White, *Art, Architecture, and Liturgical Reform*, 107, 113. See Jacques Maritain, *Art and Scholasticism*

Though "liturgical art" as a form of sacred art did not receive extensive treatment in *Liturgical Arts*, it was a common topic of discussion in early issues of *Orate Fratres*, the magazine produced under Virgil Michel at Saint John's Abbey in Collegeville, Minnesota.[15] A general definition of liturgical art that emerged was "the planning, building, and decoration of churches and all ancillary structures, the renovation and remodeling of existing buildings; the design and execution of sacred vessels, vestments, sculpture, and painting; also . . . music and other matters which are subject to liturgical usage."[16] Maritain offered three criteria for defining authentic liturgical art, saying that it must reflect the teachings of the Church, work within norms of liturgical usage, and be religious rather than academic or sentimental in its inspiration.[17] John La Farge said liturgical art "should reflect by its very nature, not only rubrical correctness but the spirit of the official worship itself, the spirit of the Church praying."[18] Liturgical art, in other words, was to fulfill a particular function. Modern art, according to the Liturgical Arts Society in 1938, had the power to play this role. Its simplicity lent great teaching power. Its abstraction reflected the ineffability of mystical experience. Its "economy of expression" was dignified; it "tend[ed] toward honesty and sincerity," depicting reality rather than illusion. It

---

(New York: Charles Scribner's Sons, 1930). While the Church certainly needed to clarify what counted as liturgical art, devotional art meant for more private prayer did not get as much attention at this time.

15. White, *Art, Architecture, and Liturgical Reform*, 112.

16. Ibid., 114.

17. Pecklers, *The Unread Vision*, 218.

18. White, *Art, Architecture, and Liturgical Reform*, 116.

represented its own time and place rather than resorting to anachronism idealizing some other historical moment.[19] Many artists and theologians within the liturgical movement were eager to embrace modern art for use in church.[20]

Yet the relationship between modern artists and the official Church remained cool for some time. In an artistic environment where creation typically was "art for art's sake," many talented modern artists did not work for the Church because they saw it as curtailing their creativity.[21] Some saw themselves as holding a prophetic role in society, which required some distance as they felt they must hold up uncomfortable truths.[22] Moreover, their work often negated intelligible representative subject matter, even if it had intelligible meaning.[23] Church documents varied in

19. Ibid.

20. One of the foremost examples of modern church architecture inspired by the liturgical movement is the Abbey Church of Saint John the Baptist in Collegeville, Minnesota. Designed by (non-Catholic) Hungarian architect Marcel Breuer (1902–1981), the simplicity of the space is noble if somewhat stark. Construction of the church between 1958 and 1961 built on developments such as the 1952 instruction on sacred art from the Congregation of the Holy Office, allowing churches to be built in new architectural styles. This reflected confident anticipation of many of the principles of liturgy and worship to issue from Vatican II just a few years later. See Seasoltz, *A Sense of the Sacred*, 252.

21. See Albert Rouet, *Liturgy and the Arts*, trans. Paul Philibert (Collegeville, MN: Liturgical Press, 1997); Peter Fingesten, "Toward a New Definition of Religious Art," *Art Journal* 10, no. 2 (Winter 1951): 131–46.

22. Pecklers, *The Unread Vision*, 230.

23. Ibid., 232. The issue of recognizability arguably was and continues to be a critical issue in sacred art. Can believers mentally and spiritually connect with the meaning depicted in images? How much

tone. In 1932, Pius XI gave an address at the dedication of the Vatican Picture Gallery referencing the 1917 Code of Canon Law as excluding "crude forms" from churches. While some saw this as a condemnation of modern art, others saw it as supporting the goals of the Liturgical Arts Society and the reform movement.[24] In 1947, Pius XII promulgated the encyclical on the liturgy *Mediator Dei et Hominum*, which gave a balanced, somewhat elastic treatment of art in the church, affirming the use of modern art but condemning any "distortion and perversion of true art."[25] In

---

does one need to know intellectually to understand one's surroundings when in a church? How does the art itself teach the faith?

24. White, *Art, Architecture, and Liturgical Reform*, 160–61; see *Pio-Benedictine Code of Canon Law: in English Translation, with Extensive Scholarly Apparatus, 1917*, trans. Edward N. Peters (San Francisco: Ignatius Press, 2001), canons 1164, 1279, and 1296.

25. Pius XII, *Mediator Dei et Hominum*, no. 195, http://www.vatican.va/holy_father/pius_xii/encyclicals/documents/hf_p-xii_enc_20111947_mediator-dei_en.html. "What We have said about music, applies to the other fine arts, especially to architecture, sculpture and painting. Recent works of art which lend themselves to the materials of modern composition, should not be universally despised and rejected through prejudice. Modern art should be given free scope in the due and reverent service of the church and the sacred rites, provided that they preserve a correct balance between styles tending neither to extreme realism nor to excessive 'symbolism,' and that the needs of the Christian community are taken into consideration rather than the particular taste or talent of the individual artist. . . . Nevertheless, . . . we cannot help deploring and condemning those works of art, recently introduced by some, which seem to be a distortion and perversion of true art and which at times openly shock Christian taste, modesty and devotion, and shamefully offend the true religious sense. These must be entirely excluded and banished from our churches, like 'anything else that is not in keeping with the sanctity of the place.'"

1952, partly as a response to the 1950 project involving non-believing artists in building the modern church at Assy, France, the Instruction of the Holy Office *De arte sacra* took a more restrictive tone regarding the use of modern art in churches.[26] Fundamentally, the tension between modern artists and the Church reflected the sensitive nature of questions regarding the balance of Church authority to determine the appropriateness of particular art for the worshiping space and the recognition of artists' inspiration and need for freedom of expression of the sacred.[27]

## Vatican II and Subsequent Guidelines for Church Art

By the time John XXIII gave his allocution on sacred art in 1961, the way was paved for a more honest and respectful interaction between the Church and the modern arts as all looked forward to the Second Vatican Council. The pope recalled other teaching from the tradition, again calling for the exclusion of any art "contrary to the holiness of the place," while describing Christian art as being almost sacramental, "a vehicle and instrument which the Lord uses to dispose souls for the wonders of grace."[28] With the 1963 Constitution on the Sacred Liturgy, *Sacrosanctum Concilium*, many of the concerns of the liturgical movement for sacred art were addressed. The goal was "noble beauty rather than sumptuous display" (SC 124). The place of modern art in

26. Pius XII, Instruction of the Holy Office *De arte sacra*, June 30, 1952, in Seasoltz, *The New Liturgy*, 174–78; White, *Art, Architecture, and Liturgical Reform*, 162–63; Irvine and Dawtry, *Art and Worship*, 36.

27. Fingesten, "Toward a New Definition of Religious Art," 143; Rouet, *Liturgy and the Arts*, 25–35.

28. John XXIII, "Sacred Art," October 28, 1961, in Seasoltz, *The New Liturgy*, 175–77.

*Quality modern liturgical art can combine abstraction and recognizability. (Crucifix, parish near Muenster Schwartz, Munsterschwarzach.)*

the Church was affirmed, but the constitution echoed *Mediator Dei*'s ban on art that is "repugnant to faith, morals, and Christian piety" identified by "lack of artistic worth, mediocrity, and pretense."[29] The Church's authority to determine the place of sacramentals and art was reaffirmed, and guidelines for appropriate art were given; no style or period of art was to be given exclusive privilege (SC 39, 122–24).[30] Five months later, Pope Paul VI also addressed Italian artists, apologizing for "caus[ing them] trouble" by imposing so many canons requiring imitation rather than true creativity and encouraging a greater friendship between artists and the Church.[31]

29. White, *Art, Architecture, and Liturgical Reform*, 164.

30. *Gaudium et Spes*, the Pastoral Constitution on the Church in the Modern World, also affirmed the value of new forms of art from around the world that might be welcomed to the sanctuary.

31. Paul VI, "Le nobili espressioni," May 7, 1964, in Seasoltz, *The New Liturgy*, 512. See also Seasoltz, *A Sense of the Sacred*, 254–55. Paul VI was one of the first popes to embrace modern art. A man of a refined aesthetic, he was attentive to papal vesture and ceremony, and he led the change in the liturgy that came into effect during his papacy. Inviting artists to produce modern religious art that could exist outside the sacred art of the liturgy, he opened a gallery of modern art at the Vatican in 1973 that displayed the work

In the years since Vatican II, other formative documents have been written dealing with the place of art in the Church. In 1971, following a massive spate of simplification of church spaces, the Congregation for the Clergy promulgated the circular letter *Opera Artis*, calling for a measure of care and respect when dealing with moving or removing valuable art within churches.[32] The US bishops' 1978 *Environment and Art in Catholic Worship* reaffirmed the liturgy as a place of holy mystery, demanding quality and appropriateness in art while reminding all that art must "serve the action of the liturgy" and not distract from it.[33] Images should be introduced after conferring with an art consultant; some images may need to be removed to enable greater focus on "primary symbols."[34] Pope John Paul II's 1999 *Letter to Artists* reflects a thoroughly Vatican II attitude, repeating references to "mystery" that echo *Lumen Gentium*'s image of the Church itself as a mystery.[35] He reaffirms

---

of Mark Chagall and other modern artists pushing the boundaries of the time.

32. Congregation on the Clergy, "Opera Artis: Circular Letter on the Care of the Church's Historical and Artistic Heritage," April 11, 1971, in ICEL, *Documents on the Liturgy 1963–1979: Conciliar, Papal, and Curial Texts* (Collegeville, MN: Liturgical Press, 1982), 1358–1360.

33. Bishops' Committee on the Liturgy, *Environment and Art in Catholic Worship* (hereafter EA) (Washington, DC: United States Catholic Conference, 1978), nos. 12, 19–23, 25.

34. Ibid., nos. 98–99.

35. John Paul II, *Letter to Artists* (hereafter LA) (Chicago: Liturgy Training Publications, 1999), nos. 10, 16: "Insofar as it seeks the beautiful . . . art is by its nature a kind of appeal to the mystery. . . . Beauty is a key to mystery and a call to transcendence. It is an invitation to savor life and to dream of the future. . . . It stirs that hidden nostalgia for God."

cooperation between artists and the Church, citing the "noble ministry" of artists when their works "reflect in some way the infinite beauty of God and raise people's minds to him."[36] He gives thanks for the didactic role of art over the ages, and citing Marie-Dominique Chenu, says that art is a genuine "source" of theology.[37] Concluding with a blessing Eastern in tone, the pope writes, "May your art help to affirm that true beauty which, as a glimmer of the Spirit of God, will transfigure matter, opening the human soul to the sense of the eternal."[38]

The US bishops' 2000 document of guidelines on art, architecture, and worship, *Built of Living Stones*, echoes the tradition of teaching on ecclesial art in a *tour de force*. No longer clearing out kitsch or defending against modernism and modern art, no longer so concerned with private devotions distracting from the primary work of liturgy, and now ready to embrace a more universal sense of the Church "catholic," the bishops give a balanced and confident treatment of the theme. Of particular interest here is the document's reclamation of the importance of private devotional prayer and the place of devotional art. After years of focusing primarily on liturgically oriented art, now we are told that churches provide space in which people may come to pray privately outside of Mass, in ways that derive from and lead back to the liturgy.[39] Thus sacred images not only are to help focus attention on the

36. Ibid., nos. 10–11.
37. Ibid., no. 11.
38. Ibid., no. 16.
39. United States Catholic Conference, *Built of Living Stones: Art, Architecture, and Worship* (hereafter BLS) (Washington, DC: United States Catholic Conference, 2000), nos. 47, 130–31; cf. SC 12–13.

liturgy but also are to guide devotional and indeed contemplative prayer; church design can create spaces that allow such devotion to complement rather than compete with liturgy.[40] "Parishes will want *both* liturgical *and* devotional art."[41] Moreover, a high standard is set: the appropriate, quality image must be able to "bear the weight of mystery, awe, reverence, and wonder" and be able to "evoke wonder at its beauty but lead beyond itself to the invisible God."[42]

## Implementation and Its Effects: What Was Found and What Was Lost

In assessing how reform of the liturgy affected devotional art, one could say some valuable benefits were gained, and some precious things were lost. Certainly a renewed sense of the primacy of the communal liturgy is a great good. "Noble simplicity" has helped bring about an era in which participants at the Eucharist now are more actively involved in the shared ritual. During the Mass, most of the congregation at least gives the appearance of focusing on the Table of the Word and the Sacrament rather than on their private devotions. Furthermore, the Church now insists on quality art, made with authentic materials; the "honesty" of sacred art matters. Moreover, much new art of varying styles from around the world has been incorporated into the life of the Church, enabling a more complete

---

40. BLS, nos. 131, 143. Note also no. 155: "Liturgical arts are integrally related to the sacraments of the Church while devotional arts are designed to enrich the spiritual life of the community and the personal piety of its members."

41. Ibid., no. 155 (emphasis mine).

42. Ibid., no. 148.

inculturation of the liturgy. To be "catholic" is to be universal. In many ways the Western Church always has been "more dynamically oriented than the East";[43] today we see the Catholic Church continue to image its universality by encompassing a variety of styles within its worship. That the Church could negotiate the difficulties posed by the less representational world of modern art—and find spiritual meaning even there—is a testament to its ability to recognize how truth can permeate all kinds of imagery, even in profound simplicity.

At the same time, the transition was not without its sacrifices. The devotional art cluttered around the sanctuary was brought to peace, but in its stead, sometimes nothing personal, recognizable, or inspiring was left. Confusing liturgical art with devotional art, many people "felt free to denude Catholic churches"; unfortunately, sometimes this resulted in the stripping of both liturgical and devotional images, with nothing left in their place: "And the People of God were left with empty barns and meeting halls."[44] Moreover, with so much emphasis on teaching people about the meaning and primacy of liturgy, popular devotion was neglected, "often derided as unsophisticated, superstitious, emotional, individualistic, reactionary, and even antiliturgical."[45] While not to be confused with litur-

43. Irina Yazykova, *Hidden and Triumphant: The Underground Struggle to Save Russian Iconography*, trans. Paul Grenier (Brewster, MA: Paraclete Press, 2010), 22.

44. Denis R. McNamara, "Images as Sacrament: Rediscovering Liturgical Art," in *Sacrosanctum Concilium and the Reform of the Liturgy* (Chicago: University of Scranton Press, 2009), 62–63, 68.

45. Peter Phan, *Directory on Popular Piety and the Liturgy: Principles and Guidelines: A Commentary* (Collegeville, MN: Liturgical Press, 2005), v.

gical prayer, devotional prayer derives from and ultimately ought to reorient the faithful toward liturgical prayer; it nourishes the spiritual life of the people. To remove art and spaces for devotional prayer without replacing them with something more appropriate is to do spiritual violence.

Fortunately, more recent documents have reaffirmed the need for both liturgical art in the sanctuary and other images in separate spaces for devotional prayer. In 2001, the Congregation for Divine Worship and the Discipline of the Sacraments issued the *Directory on Popular Piety and the Liturgy: Principles and Guidelines*, affirming the great importance of sacred images for popular piety.[46] In contrast with some of the earlier documents of liturgical reform, the directory "strongly condemn[s]" the "tendency to remove sacred images from sacred places . . . since this is detrimental for the piety of the Christian faithful."[47] As with liturgical images, devotional images are to reflect the truth of Catholic teaching. Pastors are urged to "safeguard the dignity, beauty and quality of those sacred images exposed for public veneration," assuring that the images reflect the actual devotion of the community at large and not that of isolated individuals.[48] While promoting the veneration of sacred images, the DPPL echoes Trent in making clear that images are not to be idols; the faithful venerate the one represented not because the image itself is seen as having "some divinity or power justifying such cult, nor because

46. Congregation for Divine Worship and the Discipline of the Sacraments, *Directory on Popular Piety and the Liturgy: Principles and Guidelines* (hereafter DPPL), December 2001, no. 18, http://www.vatican.va/roman_curia/congregations/ccdds/documents/rc_con_ccdds_doc_20020513_vers-direttorio_en.html.

47. DPPL, no. 243.

48. Ibid., no. 18.

something has to be requested of an image, nor because trust is reposed in them," but in order to honor the holy person whose life was configured to Christ.[49] Bishops and rectors "are to ensure that sacred images . . . are not reduced to banalities, nor risk giving rise to error."[50]

## Icons in the Wake of Vatican II

Given all the trials the modern era brought for sacred images in the Western Church, what is the state of icons in the Western Church today? As a broad category, certainly icons withstand the test of quality and worthiness posed by the various Church documents issued. Though icons in the West are not subject to the same kind of canons as in the East, as with other sacred images, they have been subjected to at least some level of oversight by the Catholic Church, which on occasion has prohibited certain kinds of images.[51] Concern that people not mistake icons for idols seems to be a perennial issue, but placing sacred images in churches for veneration continues to be affirmed.[52] It is true that in the West, perhaps excepting in small chapels, panel icons are more likely to function as de-

*Some Catholic churches incorporate icons into spaces for devotional prayer. (Our Lady of the Snows, Belleville, IL.)*

49. Ibid., no. 241.
50. Ibid., no. 18.
51. Ibid., no. 243.
52. SC 126.

votional rather than liturgical art, given their small size in relation to the magnitude of a church body. Despite all these possible limitations, icons appear to have a respectable place in the Church today, and indeed, are rising in popularity, both within the Catholic Church and also within various Protestant denominations.

Of current concern are several issues. First, who is to determine the requisite level of quality for icons in the West? The majority of priests and faithful in the West have not studied the Eastern canons for iconography, and with a plethora of new painters trying their hand at writing icons, with few good prototypes to consult and fewer true master teachers available, much iconography of deplorable quality and questionable orthodoxy is being propagated. Secondly, then, is the question of "orthodox" imagery for icons in the West. Ought Western icons to be subject to the same standards of depiction as in the East? Can we allow icons of the Holy Family, with Joseph's arm around Mary, if such a gesture is seen as symbolic of the marital embrace in the East? Are haloes of different colors allowed? Do we maintain the Eastern sensibility that only canonized saints may be depicted with a halo in an icon? The Catholic Church may be open to a variety of different forms and styles for sacred art, but in the realm of icons, at a certain point such individual artistic license causes a work to cease to be an icon. Where should the lines be drawn?

Church design consultant Richard Vosko considers placing icons in Latin Rite Catholic churches a "curious" practice, though he believes it may be a result of the ecumenical spirit coming out of Vatican II.[53] He rightly notes that the

53. Richard S. Vosko, *God's House Is Our House: Re-imagining the Environment for Worship* (Collegeville, MN: Liturgical Press, 2006), 136.

authentic icon is in some ways different from other sacred art. In the West, we need to be aware of the traditional training and spiritual and moral expectations of iconographers that may not affect other church artists.[54] If in the West we choose to incorporate icons into our churches, do we maintain these Eastern standards? Vosko also raises concern that true icons be venerated properly. Unlike other Western sacred art, the "true icon is not considered a portrayal but the embodiment or 'real presence' of God, Mary or some other saint."[55] He notes, however, that in many Roman Catholic churches today, icons often are treated just like other statues or paintings, as decoration. If we are to share the understanding of what an icon is with the East, congregations need to be educated before including icons in their churches. In a Catholic world of such diversity in images and styles, can icons expect special treatment?

## *Sacramentality and Orientation in the Roman Church*

At the heart of this concern for proper treatment of icons is a fundamentally unresolved issue of sacramentality: Where is our locus of the sacred? In contrast with the Eastern Church, which does not reserve the Eucharist after liturgy for adoration, in the West, outside of Mass, the Blessed Sacrament reserved in the tabernacle usually is the primary place of orientation in most churches. When entering a church, Catholics tend to look for a lit candle indicating its location. If visibly present, it becomes the direction in which one genuflects. Since Vatican II, many churches have consigned the tabernacle to a separate chapel for

54. Ibid., 136–37.
55. Ibid., 137.

prayerful devotion outside Mass, so as to keep the main focus on Christ present in the liturgy itself.[56] Thus attention is shifted to the altar, to which one bows or genuflects as it is a symbol of Christ, "the Living Stone."[57] Certainly, within the liturgy, the altar is the main focal point, joined by the ambo, the "Table of the Word." Yet as Van Ausdell notes in her essay on imagery and eucharistic contact, since medieval times, a crucifix usually above or behind the altar also has been a focal point for devotion, enabling visualization of the reality occurring on the altar (and, I would add, in the community) during Eucharist. Even if the crucifix is not itself recognized as the official sacramental presence of Christ, it is an artistic locus of the sacred intimately tied to the liturgical action, enabling fuller participation in it. It is sacred liturgical art that helps orient the congregation toward God's presence.

In the East, apart from the Eucharist in the liturgy itself, icons are the primary locus of the sacred. They are the embodied "real presence" of Christ in his own image and in that of his saints. They may be revered at home, in church, in processions, and in other public places. Thus the sacred, in a way, is somewhat diffused, sacralizing the

---

56. Sometimes poor layout or signage can make it difficult even to locate a Blessed Sacrament chapel. We say that the Eucharist is "the source and summit" of Catholic life, meaning it is the sacramental presence of Christ toward which everything else is oriented. Spatially, this ought to be true as well. If we cannot even find the tabernacle that once was the defining point of spatial orientation in a Catholic church, does this mean our definition of Eucharist has broadened, or that we have become so disoriented that we lack any living locus of the sacred?

57. GIRM, no. 298 (cf. 1 Pet 2:4).

wider culture. In the Catholic Church, we stand as yet on the heels of a council very concerned to reassert the primacy of liturgy as the focal point of sacred encounter. Can the West come to recognize sacramental presence in yet another place? Would promoting an Eastern understanding of reverence for icons compromise Western liturgical sensibilities and undo the "progress" made since the era of individual devotionalism during Mass, or could it come to serve the liturgy by cultivating a more sacramental sense of life and the world?

Rather than diluting the meaning of the liturgy, I believe a theologically grounded devotion to icons has great potential to serve the liturgy in the West. Coupled with a greater appreciation of the theology of theosis, or deification, icons stand to teach the West much about the meaning of the communion of saints and how we among the living participate with those in heaven, especially when we join together to celebrate the eucharistic liturgy.

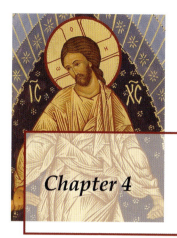

## Chapter 4     Engaging the East

*A Western Defense of Icons*

At last we come to the critical questions. Why should the West embrace icons? In light of how our tradition differs from that of the Eastern Church, how could icons be considered appropriate for usage in the Catholic Church today? Theologically and in practice, what is rightly the patrimony of the East alone, and what is rather the more universal patrimony of the Church catholic, both Latin and Orthodox? Because the Catholic Church has committed to remaining open to the forms of art of every age, as a form of *ressourcement*, icons should be given their rightful place in the West. As manifestations of the greater shared tradition of Christianity, they are not simply decoration but carriers of sacramental presence due their own form of veneration.

### *Returning to the East:*
### *Primary Arguments for "Presence" in Icons*

As the first home of Christianity, the Church in the East reflects something of the original root system of the faith

in a privileged way.[1] This is not to say that the Western Church has been completely uprooted from its critical life source; the deposit of faith is not bound by geography. Still, in the transplanting of the faith, different soil has allowed Western Christianity to be inculturated and to grow in its own manner. Certainly the vicissitudes of history and interaction with the broader world have meant that the Orthodox Church likewise has developed with time. At a fundamental level, however, the Eastern Church has protected some eternal values and long-standing traditions that by right belong to the wider Church. The theology of icons is one such tradition. In order for the Catholic Church to understand and use icons properly, due acknowledgment of the Eastern tradition is necessary.

The present difficulty of the West with accommodating icons reflects an awkwardness surrounding what kind of veneration is both appropriate to the icon and natural to people of today. Some Catholics have an intuitive or catechized sense of the "presence" in icons, but most are unaware, considering icons to be simply an old form of decoration for churches. Aesthetically, icons do not necessarily appeal to everyone, as some stylization appears strange or distorted. Their beauty is not simply a sort of "pretty"; some icons can be unsettling in the intensity of the gaze leveled. Yet however it is perceived, the personal nature of such representative sacred art invites some kind of interaction.

1. John Paul II, *Orientale Lumen* (hereafter OL), May 2, 1995, no. 1, http://www.vatican.va/holy_father/john_paul_ii/apost_letters/documents/hf_jp-ii_apl_02051995_orientale-lumen_en.html.

If the West is to come to a level of comfort with icons, it is necessary first to engage the Eastern understanding of what an icon is. In their eighth-century response to iconoclasm, John of Damascus and Theodore of Studios provide the classical articulation of what icons are and why they are appropriate for veneration. Their arguments still resonate today. First, John and Theodore address the fundamental anxiety that the icon might be an idol, noting that the Old Testament prohibitions against creating images reflected a concern to worship God alone. At the time the law was given, God had not yet become visible and so a prohibition on creating or giving honor to images was fitting.[2] John argues, however, that after the incarnation, "when the invisible [had become] visible in the flesh, then [it was acceptable to] depict the likeness of something seen."[3] Thus the incarnation of Christ is the model for icons. In the incarnation, humanity and divinity were brought together as a particularly intimate aspect of God in the Trinity, so that Christians no longer can worship God independently of the humanity of Christ.[4] Moreover, because Christ is the image, or *eikon*, of God, images are a fundamental part of ultimate reality, critical to our ability to grasp the meaning of creation.[5] Furthermore, as God is the first

2. John of Damascus, "Against Those Who Attack the Holy Images," 1.4.6-7; 3.6, in *Three Treatises on the Divine Images*, trans. Andrew Louth (Crestwood, NY: St. Vladimir's Seminary Press, 2003), 22–23, 85–86.

3. Ibid., 1.8, p. 24.

4. George D. Dragas, *Ecclesiasticus II: Orthodox Icons, Saints, Feasts and Prayer* (Rollinsford, NH: Orthodox Research Institute, 2005), 40.

5. Andrew Louth, " 'Beauty Will Save the World': The Formation of Byzantine Spirituality," *Theology Today* 61 (2004): 74.

image maker, and humanity is created in the image and likeness of God, so humans are called to make images.[6]

In terms of the dignity of the icon, John of Damascus, Theodore of Studios, and those of the antique world before them draw on standard Greek philosophical categories of form and matter to understand how the image is intimately connected with its prototype.[7] In the Platonic world, what is seen in matter is an image of its unseen higher ideal form; Aristotle, by contrast, posited that ultimate reality is present here in tangible matter. In terms of icons, as St. Basil taught, to the extent that the image also is the likeness of its prototype, honor given to the material image passes on to the one depicted.[8] Kenneth Parry explains: "Although there is a difference in essence between image and prototype, there is an identity of likeness which means the two are venerated together."[9] As the humanity and divinity of Christ are connected, so are the image and its prototype. If Christ is both human and divine, his two natures hypostatically joined in one person, then, though we see only his humanity and not his unknowable divine essence, the authentic image of him puts us in the presence of both the human and divine.[10] Theodore of Studios ar-

6. Ibid., 74.

7. Kenneth Parry, *Depicting the Word: Byzantine Iconophile Thought of the Eighth and Ninth Centuries* (New York: E. J. Brill, 1996), 22–26.

8. Cf. Basil the Great, *On the Holy Spirit*, 18.45, trans. David Anderson (Crestwood, NY: St. Vladimir's Seminary Press, 1980), 72–73. Because icons depict the saints in their deified state, they reflect not only their human image but also their original likeness to God.

9. Parry, *Depicting the Word*, 25.

10. Irina Yazykova, *Hidden and Triumphant: The Underground Struggle to Save Russian Iconography*, trans. Paul Grenier (Brewster, MA: Paraclete Press, 2010), 2; Hans Belting, *Likeness and Presence*, trans. Ed-

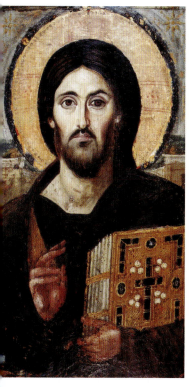

ticulates the unity of Christ with his icon by saying that just as adoration of Christ is adoration of the Father because they share the same divine nature, so reverence of the icon of Christ is due to Christ himself, even if it involves reverencing a physical object rather than a visible physical person: "The very same person is being worshipped, even though he has been circumscribed [literally, drawn] in the icon."[11] Thus John of Damascus can speak of the dignity due to matter:

*One of the fundamental arguments for the veneration of icons is that when God became visible in the person of Christ, creating images gained new dignity. Rather than drawing people into idolatry, images now could connect humanity to God. (Wax encaustic icon of Christ, sixth century, Saint Catherine's Monastery, Sinai, Egypt.)*

mund Jephcott (Chicago: University of Chicago Press, 1994), 7; Gianluca Busi, *Il segno de Giona* (Bologna: Dehoniana Libri, 2011), 51.

11. Theodore of Studios, *Epistola ad Platonem de cultu sacrarum imaginum*, PG 99, 500–505, as cited in Thomas F. Mathews, "Psychological Dimensions in the Art of Eastern Christendom," in *Art and Religion: Faith, Form, and Reform*, ed. Osmond Overby (Columbia, MO: University of Missouri Press, 1986), 11.

> I depict what I have seen of God. I do not venerate matter,
> I venerate the fashioner of matter, who became matter for
> my sake and accepted to dwell in matter and through
> matter worked my salvation, and I will not cease from
> reverencing matter, through which my salvation was
> worked. . . . [I]t is filled with divine energy and grace.[12]

The divine power in an icon, then, is not derived from the
matter itself but due to its being coupled with the unseen
spiritual nature of the one depicted.[13] Not merely a philo-
sophical symbol or imitation, the icon has a theological,
mystagogical character that leads from the human to the
divine, "from the created to the uncreated, uniting them
according to the sanctifying grace of Christ."[14] In the Ortho-
dox view, then, icons serve to remind us of the "sanctifying
energy of God" present in our world, sanctifying the sense
of sight just as perceiving Scripture sanctifies hearing.[15]

Central to the Eastern understanding of the incarnation
and to icons is the concept of redemption by theosis, or
divinization. Just as God became visible human flesh for
our sake, so we are called to be remade by cooperation with
God's grace to our original image and likeness of God. The
idea of theosis is based on passages like Psalm 82:6, "I say,
you are gods," and 2 Peter 1:4, "you shall become partakers
of the divine nature," though it also reflects a particular

---

12. John of Damascus, "Against Those Who Attack the Holy Im-
ages," 1.16, p. 29; cf. Marjorie O'Rourke Boyle, "Christ the Eikon in
the Apologies for Holy Images of John of Damascus," *Greek Ortho-
dox Theological Review* 15 (1970): 179.

13. Parry, *Depicting the Word*, 38.

14. Dragas, *Ecclesiasticus II*, 19.

15. John of Damascus, "Against Those Who Attack the Holy Im-
ages," 1.17, p. 31; Dragas, *Ecclesiasticus II*, 48.

understanding of the wider biblical tradition.[16] Sanctification is thus seen as an ongoing process beginning with baptism; Christ's incarnation gives us an image and goal on which to focus as we continue to participate with grace through the sacramental life of the Church and contemplative prayer.[17] According to John of Damascus, just as Christ did not lose his divinity in becoming human, so we retain our humanity even as we are made divine: "It is by means of the incarnation that Christ deifies our flesh and sanctifies us by surrendering his Godhead to our flesh without confusion."[18] This glorification of human nature is what brings about Christian salvation and allows creation of images of the saints as well as of Christ.[19] Inasmuch as saints are deified and participate in the glory of God, they image for us divine reality in human form. Salvation by theosis thus is the way Eastern Christianity is oriented toward right relationship with God. Moreover, a desire to honor God's presence among deified humanity leads the Orthodox to venerate icons.

While theosis is more emphasized in Orthodoxy than in the Catholic Church (which tends to focus more on the sinfulness of humanity needing redemption by the paschal mystery), as part of the ancient tradition of the Church, theosis as a concept is properly the domain of both East and West. Already the belief is part of Western usage, as

16. Parry, *Depicting the Word*, 119.

17. Ibid., 119–20.

18. John of Damascus, "Against Those Who Attack the Holy Images," 1.2, p. 35; Parry, *Depicting the Word*, 122.

19. John of Damascus, "Against Those Who Attack the Holy Images," 2.10, pp. 67–68; Parry, *Depicting the Word*, 124.

seen in the eucharistic prayer said quietly by the priest when adding a little water to the wine:

> By the mystery of this water and wine
> may we come to share in the divinity of Christ
> who humbled himself to share in our humanity.[20]

For the Catholic Church to give greater emphasis to deification would bring greater balance to what sometimes can be its overly negative Augustinian anthropology. Theosis and the icon celebrate a world already redeemed by Christ. As individuals, we continue in the process of sanctification, and while the world is still a sinful place, ultimately, this perspective on redemption allows greater emphasis on the presence of God even in the midst of suffering and imperfection.

### *The Icon in Western Terms: Presence and Sacramentality*

For Catholics to understand the holiness and "presence" of icons, it is necessary to relate them not only to the Eastern idea of resonance with a redeemed prototype but also to the sacramentality of the real presence of Christ in the Eucharist and the other sacraments of the Church. After all, in Western theology, devotional prayer, with its attendant devotional art, derives from and is to lead back to liturgy.[21] A *sacrament* in its traditional definition is a visible sign instituted by Christ and entrusted to the Church to

---

20. *The Roman Missal: English Translation According to the Third Typical Edition* (Chicago: Liturgy Training Publications, 2011), 529.
21. Cf. SC 10–13; EA no. 25.

give grace.[22] In other words, it makes visibly present an unseen world, and via our participation in it, God offers us grace. As embodied humans, we know things through concrete reality. The only way we can speak of the spiritual world is by using analogies from the physical world we know. We need images, whether mental or visual. It is in this manner of speaking that we encounter God through the signs and symbols of bread, wine, water, and oil in sacramental life, and it is in this sense that John of Damascus says the icon serves to make visible the invisible, to help us understand God.[23] In his *Letter to Artists*, Pope John Paul II also says that the icon is, in a sense, a sacrament, working by analogy to make present the mystery of the incarnation.[24]

By contrast, *sacramentals* of the Church work with the liturgy both by preparing the disposition of the faithful to receive sacraments and by extending liturgical life into the wider arena of the everyday.[25] Along with other sacred art, holy water, blessed palms, and rosaries, icons could be

---

22. *Catechism of the Catholic Church* (hereafter CCC), no. 1131, http://www.vatican.va/archive/ENG0015/_INDEX.HTM: "The sacraments are efficacious signs of grace, instituted by Christ and entrusted to the Church, by which divine life is dispensed to us. The visible rites by which the sacraments are celebrated signify and make present the graces proper to each sacrament. They bear fruit in those who receive them with the required dispositions."

23. Yazykova, *Hidden and Triumphant*, 2; John of Damascus, "Against Those Who Attack the Holy Images," 1.11, p. 26.

24. LA, no. 18.

25. CCC, nos. 1668, 1674–1675; Raúl R. Gómez, "Veneration of the Saints and *Beati*," in *Directory on Popular Piety and the Liturgy: Principles and Guidelines; A Commentary*, ed. Peter C. Phan (Collegeville, MN: Liturgical Press, 2005), 128.

considered sacramentals. The 1983 Code of Canon Law defines sacramentals as "sacred signs by which effects, especially spiritual effects, are signified in some imitation of the sacraments and are obtained through the intercession of the Church."[26] "In other words," explains Raúl Gómez,

> Sacramentals are similar to sacraments but differ from them both in their origin and efficacy. They are instituted by the church rather than by Christ, and they bring about their spiritual effects by the prayer of the church—*ex opere operantis* (by the work of the agent) rather than by the performance of the work—*ex opere operato* (by the work performed).[27]

Are icons sacraments or sacramentals? They draw from the definitions of both. It is perhaps in reflecting on this dual nature that John Paul II writes that icons are "in a sense" sacraments: "By analogy with what occurs in the sacraments, the icon makes present the mystery of the incarnation in one or another of its aspects."[28] Certainly icons are visible, sacred signs. Used in prayer, they act as sacramentals as they aid preparation of the right disposition for receiving the sacraments. While some may argue that icons were not instituted by Christ but rather by the Church and so are sacramental rather than sacrament, we could also say that as Christ is the first icon of God, so icons are insti-

26. Canon Law Society of America, *Code of Canon Law: Latin-English Edition* (Washington, DC: Canon Law Society of America, 1989), can. 1166.

27. Gómez, "Veneration of the Saints and *Beati*," 128. Cf. John H. Huels, Commentary on can. 1166, in *New Commentary on the Code of Canon Law*, ed. John P. Beal, et al. (New York: Paulist Press, 2000), 1401.

28. LA, no. 8; cf. McNamara, "Image as Sacrament," 58–59.

tuted by Christ and not simply the Church and so are sacrament. In considering the last part of the definition of a sacrament, though, we must consider how icons are in fact "efficacious signs" that "give grace." That icons give grace is what sets them apart from much other religious art. Yet is the icon's power a result of the prayers of the person praying before it (working *ex opere operantis*), or is the power rather intrinsic to the icon itself, free to work in itself (*ex opere operato*) regardless of the one praying before it?

The icon does not readily fit into categories used by the Western Church. I would argue that while fundamentally a sacramental, the icon tends toward being a sacrament, though its fruitfulness, as with the seven canonic sacraments of the Church, depends on the disposition of the one receiving it. In the Eastern understanding of the icon, the power is in the icon itself, a resonance between the image and the holiness of the one who is its prototype, and when people pray to the saints through their icons, the saints are present. Orthodox theologian Leonid Ouspensky explains:

> The icon is an image not only of a living but also of a deified prototype. . . . [T]his is why grace, characteristic of the prototype, is present in the icon. In other words, it is the grace of the Holy Spirit which sustains the holiness of both the represented person and of his [or her] icon. . . . [T]he icon participates in the holiness of its prototype and, through the icon, we in turn participate in this holiness in our prayers.[29]

29. Leonid Ouspensky, *Theology of the Icon* (Crestwood, NY: St. Vladimir's Seminary Press, 1978), 191.

Just as the divinity of Christ cannot be separated from his humanity, so the holiness of the saints cannot be separated from their images. Prayer is the link to grace, but the Holy Spirit is the one who gives power both to the deified saint and to his or her image. Moreover, even if it is prayer that gives a sacramental its power, it is not merely the prayer of the one praying before the icon that effects its "presence." From the moment an iconographer begins to create, the work is suffused with prayer connecting the human world with the spiritual world of heaven.[30] Painted not simply for oneself but as an offering and a tool for the spiritual welfare of others, the authentic icon is a gift of communion both among those on earth and those in heaven.[31] Presuming the image created reflects the person represented, is it any surprise that those of heaven would respond to this prayer and love with their presence? Even before anyone chooses to pray before an icon, the prayer of the iconographer has already been connecting the image with its holy prototype. As for proof of icons' power, the Eastern Church is full of stories of icons that have worked miracles, particularly when connected with prayer, but occasionally even apart from it, as when icons have indicated their desire to be moved to other locations, or when barring entrance of something or someone unholy.[32] In

---

30. Christopher Irvine and Anne Dawtry, *Art and Worship* (Collegeville, MN: Liturgical Press, 2002), 68.

31. Yazykova, *Hidden and Triumphant*, 3. The Orthodox expectations for the behavior and spirituality of iconographers reflect norms similar to those held for priests, because the artist similarly holds a task of fostering relationship with Jesus.

32. Ernst Kitzinger, "The Cult of Images in the Age before Iconoclasm," *Dumbarton Oaks Papers* 8 (1954): 101–12.

some very real way, then, the icon is a special kind of portal of the holy.

### Engaging the East:
### Western Affirmation of Veneration Due Icons

How we physically are to relate to the holy encountered in this world is the matter of veneration. Literally, veneration (*proskynêsis*) means to bow down and possibly to touch with the mouth or lips. It may involve anything from a bow to a kiss to a full prostration. Yet what is implied by such an action may differ. In earlier times, people regularly would bow down to the emperor yet did not necessarily perceive him to be God. John of Damascus differentiates between the veneration or worship due to God alone (*latria*, or adoration) and the veneration of devotion, honor, and respect due to the saints (*dulia*), citing Old Testament examples involving Jacob, Esau, Joseph, and David venerating another person, an angel, or the place of God.[33] It is this latter kind of veneration that is due to images of either Christ or the saints.[34]

Though veneration of images may seem a rather foreign concept to some contemporary Catholics, it is, in fact, a part of the Western tradition as well, though perhaps less commonly seen since Vatican II. Prior to Vatican II, the rite of profession of faith for converts to Catholicism included a statement of affirmation of the practice, reflecting the Catholic response to Reformation controversies: "I profess

33. John of Damascus, "Against Those Who Attack the Holy Images," 1.14, pp. 27–28.

34. Andrew Louth, *St. John Damascene: Tradition and Originality in Byzantine Theology* (New York: Oxford University Press, 2002), 201.

*While not as common in post–Vatican II Catholicism, veneration of holy images has long been part of Catholic tradition. The foot of the statue of St. Peter at the Vatican has been worn smooth by years of affectionate touch in veneration.*

firmly that the images of Jesus Christ and of the Mother of God, ever-virgin, as well as of all the saints, should be given due honor and veneration."[35] Yet even without this profession today, the Church continues to teach the value of venerating images. Echoing other Church documents, the 2010 *General Instruction* directs that "venerating the memory of the Saints" is part of connecting our earthly liturgy with that of heaven; "in sacred buildings images of the Lord, of the Blessed Virgin Mary, and of the Saints, in accordance with the most ancient tradition of the Church, should be displayed for veneration by the faithful."[36] In the 2001 *Directory on Popular Piety and the Liturgy*, the Congregation for Divine Worship and the Discipline of the Sacraments also reaffirms the value of venerating images of the saints, citing the doctrines of Nicaea II.[37] While warning that the faithful need

35. Maxwell Johnson, *Rites of Christian Initiation: Their Evolution and Interpretation* (Collegeville, MN: Liturgical Press, 2007), 435n130; R. Kevin Seasoltz, *A Sense of the Sacred* (New York: Continuum, 2005), 169.

36. GIRM, no. 318; cf. BLS, nos. 156–57; Theodore Alois Buckley, *The Canons and Decrees of the Council of Trent* (London: Routledge, 1851), Session 25, pp. 214–15; SC 111, 125; LG 51, 61, 67.

37. DPPL, no. 238.

constant reminders about the doctrine of veneration so as not to fall into idolatry, they do see veneration as an important part of popular piety, which may occur in a church, at home, in processions, or at shrines along the road.[38]

The Catholic Church has also promoted icons in particular as being worthy of veneration. In 1987, John Paul II wrote his apostolic letter *Duodecimum Saeculum*, commemorating the 1200th anniversary of the Second Council of Nicaea (787), which defined the Church's stance toward icons and was the last council recognized by both the Catholic and the Orthodox Churches. The pope cites Nicaea II's affirmation of both the written and unwritten traditions of the Church as being normative, adding that Vatican II similarly affirmed tradition as well as Scripture as a vehicle of revelation.[39] He repeats the council's affirmation of the distinction between true adoration directed toward God (*latreia*) and the honor of veneration given to icons (*timetike proskynesis*).[40] Commenting on how the doctrine of Nicaea II has "nourished the art of the Church in the West as much as in the East," he makes the point that in the West, Rome has had an unbroken tradition of favoring sacred images, especially during the critical years between 825 and 843, but also especially at

38. Ibid., no. 239.

39. John Paul II, *Duodecimum Saeculum* (hereafter DS), December 4, 1987, no. 7, http://www.vatican.va/holy_father/john_paul_ii /apost_letters/documents/hf_jp-ii_apl_19871204_duodecim -saeculum_en.html; cf. Second Vatican Council, *Dei Verbum* (Dogmatic Constitution on Divine Revelation) (hereafter DV) 10, in *Vatican Council II: The Conciliar and Postconciliar Documents*, rev. ed. (Collegeville, MN: Liturgical Press, 2014).

40. DS, no. 9.

the Council of Trent and Vatican II.[41] He notes the resurgence of interest in the theology and spirituality of icons in the West, encouraging his fellow bishops to

> "maintain firmly the practice of proposing to the faithful the veneration of sacred images in the churches" [SC 122–24] and do everything so that more works of truly ecclesial quality may be produced. The believer of today, like the one of yesterday, must be helped in his [or her] prayer and spiritual life by seeing works that attempt to express the mystery and never hide it.[42]

In the modern world, he sees the rediscovery of the icon as countering the depersonalizing and degrading power of other kinds of images in secular culture.[43] The icon is a special tool for evangelization, as "the language of beauty placed at the service of faith is capable of reaching people's hearts and making them know from within the One whom we dare to represent in images."[44]

In his 1995 apostolic letter *Orientale Lumen*, regarding ecumenism with the Eastern Churches, John Paul II recommends that the Latin Church "get fully acquainted with" the "treasure" of the Eastern tradition, restoring catholicity to the Church and the world, but he does not explicitly mention icons.[45] In his 2003 *Ecclesia de Eucharistia*, an encyclical letter dealing with problems related to

---

41. Ibid., no. 10. From 825 to 843, both the Byzantine and Frankish Empires were hostile to Nicaea II, but Rome supported it.
42. Ibid., no. 11.
43. Ibid.
44. Ibid., no. 12.
45. OL, no. 1; Busi, *Il segno de Giona*, 62, 65.

the cult of the Eucharist, he again addresses the topic of sacred images, expressing thanks for the contribution of the Greco-Byzantine tradition of architecture and mosaics; he also uses the image of Andrei Rublev's icon of the Trinity as an analogy for the "Eucharistic Church."[46] Also during the pontificate of this Slavic pope, the value of contemplating icons with meditation on Scripture was affirmed in the 1992 *Catechism of the Catholic Church*, where Nicaea II is again cited as justifying the cult of icons.[47]

Coming from a more Western perspective, in *Built of Living Stones*, the US bishops reaffirm the modern Catholic

46. John Paul II, *Ecclesia de Eucharistia* (hereafter EE), April 17, 2003, no. 50, http://www.vatican.va/holy_father/special_features /encyclicals/documents/hf_jp-ii_enc_20030417_ecclesia_eucharistia _en.html; Busi, *Il segno de Giona*, 63.

47. CCC, nos. 1159–1162, 2131–2132, 2691; Busi, *Il segno de Giona*, 64. CCC, nos. 1159–1162: "The sacred image, the liturgical icon, principally represents Christ. It cannot represent the invisible and incomprehensible God, but the incarnation of the Son of God has ushered in a new 'economy' of images. . . . Christian iconography expresses in images the same Gospel message that Scripture communicates by words. Image and word illuminate each other. . . . All the signs in the liturgical celebrations are related to Christ: as are sacred images of the holy Mother of God and of the saints as well. They truly signify Christ, who is glorified in them. They make manifest the 'cloud of witnesses' who continue to participate in the salvation of the world and to whom we are united, above all in sacramental celebrations. Through their icons, it is [humanity] 'in the image of God,' finally transfigured 'into his likeness,' who is revealed to our faith. So too are the angels, who also are recapitulated in Christ. . . . Similarly, the contemplation of sacred icons, united with meditation on the Word of God and the singing of liturgical hymns, enters into the harmony of the signs of celebration so that the mystery celebrated is imprinted in the heart's memory and is then expressed in the new life of the faithful."

position that the Church is not wedded to any single style of artistic expression, but they do hold up criteria for sacred art that many icons are in a good position to meet: it must be of "the highest artistic standard . . . in order that art may aid faith and devotion and be true to the reality it is to symbolize and the purpose it is to serve."[48] It should "bring the divine to the human world, to the level of the sense, then, from the spiritual insight gained through the senses and the stirring of the emotions, to raise the human world to God."[49] The quality religious image is marked by "honesty and genuineness of materials," "nobility of form," "love and care" in its creation, and "the personal stamp of the artist whose special gift produces a harmonious whole, a well-crafted work."[50] Ultimately, art that is "worthy of the Christian assembly" must "evoke wonder at its beauty but lead beyond itself to the invisible God."[51] They mention icons among the kinds of sacred images that raise awareness of the communion of saints and "draw us into the deeper realities of faith and hope."[52] Moreover, the bishops encourage popular devotions, com-

48. BLS, nos. 40–45, p. 15n55; cf. SC 123; GIRM, no. 289.

49. BLS, no. 142.

50. Ibid., no. 146. Regarding the "personal stamp" of the artist, while icons may be seen as a form of art where the artist's personality is obscured, in the traditional Eastern understanding, the iconographer's personality and spirituality are of the greatest importance precisely because they affect the spiritual quality of the image produced. It also may be that the bishops here are referencing concerns about mass production and the need for a real, personal artist to produce authentic work of skill.

51. Ibid., no. 148.

52. Ibid., nos. 135–36.

menting that sacred images aid in "help[ing] the faithful to focus their attention and their prayer."[53]

## Veneration of Icons in the West Today

In the West, then, despite some question of where the source of power is with icons, we acknowledge them at least as a special kind of sacramental, and Church documents support their veneration, but when it comes down to the practicalities of everyday life, Catholics hesitate to give to icons the full weight of veneration that they receive in the East. Genuflection before the tabernacle and bowing to the altar are ordinary enough practices, and while perhaps uncomfortable for some, the Good Friday veneration of the Cross provides a ritual space for reverence by kissing.[54] Generally speaking, though, in a typical Latin Rite Catholic Church, one would be hard pressed to find anyone kissing images or making full prostrations to icons or other religious images while entering to prepare for liturgy. These are intimate yet public Eastern customs tied to ancient ways of respecting an emperor that somehow got lost in translation. In Western churches, religious art, of whatever variety, more commonly tends to be decoration.

---

53. Ibid., nos. 130–31.

54. GIRM, no. 274: "A genuflection, made by bending the right knee to the ground, signifies adoration, and therefore it is reserved for the Most Blessed Sacrament, as well as for the Holy Cross from the solemn adoration during the liturgical celebration on Good Friday until the beginning of the Easter Vigil." GIRM, no. 275: "A bow signifies reverence and honor shown to the persons themselves or to the signs that represent them. There are two kinds of bows: a bow of the head and a bow of the body. . . . A bow of the body, that is to say, a profound bow, is made to the altar."

Some of the difficulty today's Catholics experience with venerating images of Jesus and the saints is simply a product of nonexposure and perhaps the secularization of the culture. In the vast simplification that occurred in many churches after Vatican II, many liturgical and devotional images were eliminated altogether. Without the opportunity to regularly, sensibly envision the saints as a part of liturgical worship, the practice of interacting with images of the saints has become somewhat foreign to many Catholics, even in devotional prayer. Cultural trends, at least in the United States, continue to relegate religious behavior more and more into the private rather than the public sphere. Many would consider kissing an icon too personal a gesture to be comfortable for public veneration.[55] Moreover, the culture at large in many ways could be said to be image saturated. With so many disposable, meaningless images in the media, it may be that sacred images themselves seem to have less power than they once did. If sacred images are lacking in shared public prayer, it seems unreasonable to expect the faithful to cultivate use of images in their private prayer. Fortunately, it appears the Church is beginning to reclaim the importance of images as aids to both liturgical and devotional prayer.

For all the "visual illiteracy" that seems to plague Catholicism, it seems Catholics do still embrace a range of ways to show devotion and honor to God and the saints through religious images. Place a prie-dieu before a statue

55. See Claire Maria Chambers, "The Common and the Holy: What Icons Teach Us about Performance," *Liturgy* 28, no. 1 (January 2013): 18–30, for a contrast with the Eastern Orthodox practice of public devotion to icons.

or icon in a side chapel or other area for private prayer and Catholics will kneel to pray. Make votive candles available before an image and Catholics will light them. Place a statue at eye level and Catholics will touch it; the feet of the statue of St. Peter at the Vatican are rubbed smooth from the affection of so many pilgrims. Do Catholics venerate images? While perhaps the Catholic understanding of "veneration" differs somewhat from its literal and more Eastern meaning of "to bow down" or "kissing toward," it appears that, yes, Catholics are capable of devotional behavior that could be considered veneration. What seems necessary to encourage greater veneration for Jesus and the saints as depicted in icons is provision of the appropriate context to suggest devotional behavior and prayer. Paired with quality, appropriate liturgical art, wider catechesis as to what an icon is, and a greater understanding of the importance of the communion of saints, such reshaping of the environment for prayer holds promise to deepen the faith of Christians in the West.

*It is important to provide an appropriate context for interaction with a sacred image, such as the opportunity to light a candle or kneel to pray. (Exeter Cathedral, Devon, England.)*

**Chapter 5**

# Possible Directions for Increased Western Use of Icons

Icons are images that can function in various ways depending on their relationship to liturgical rites. Consequently, in order to promote prayer with icons in the Western Catholic Church, icons need to be presented to the faithful in appropriate contexts that suggest the most fitting kind of interaction. It is important to be mindful of which kind of icon is best suited to each situation. Given the rich history of the West with other kinds of images, it also is necessary to establish how icons are different and to ascertain how they might best fit into this wider array of sacred images. Moreover, some catechesis is desirable, as icons in many ways are a rather new phenomenon in Western churches.

Italian priest and iconographer Gianluca Busi notes that though Church documents have voiced some level of support for using icons in churches, the magisterium has not given particular directives on how best to integrate them into liturgical space or what kind of veneration they ought to be accorded. He suggests that while we await more

particular directives from the magisterium, for now, place-
ment of icons in Catholic churches appears to be somewhat
open for exploration.[1] Busi considers the 1992 *Catechism*
as the document most explicitly addressing the issue of
how to integrate icons into Western spaces, which, "while
formulating a general appreciation" for the icon,

> limits us in fact to noting that these images can be "useful
> for prayer," especially in relation to personal devotion.
> Much more cautious is the affirmation regarding [icons
> in use during] worship, since it is stated that the icons
> should be placed—if present in a building used for wor-
> ship—in a "prayer corner," and therefore not in the main
> hall where it is celebrated.[2]

Though he surveys Church teaching on icons from a num-
ber of sources, it appears that Busi may be unfamiliar with

1. Gianluca Busi, *Il segno de Giona* (Bologna: Dehoniana Libri, 2011),
98, my translation: "It will be necessary then to wait for a more in-depth
reflection, with its consequent instructions, on the part of the magiste-
rium. For the moment, the presence of icons in churches is tied to a
question for the most part concerning practical requirements and is
being tolerated." ("Occorrerà poi aspettare una più approfondita rifles-
sione, con conseguenti indicazioni, da parte del Magistero. Per il mo-
mento la presenza della icone nei luoghi di culto e legato ad una
domanda che proviene per lo piu da esigenze concrete, è viene tolle-
rata.") Cf. Denis R. McNamara, *Catholic Church Architecture and the
Spirit of the Liturgy* (Chicago: Liturgy Training Publications, 2009), 135.

2. Busi, *Il segno de Giona*, 65, referencing CCC, no. 2691, my trans-
lation. ("Pur formulando un apprezzamento generale, ci si limita
di fatto a notare che queste immagini possono essere 'funzionale
alla preghiera,' soprattutto in relazione alla devozione personale.
Molto più cauta l'affermazione per quanto riguarda il culto, poichè
si afferma che le icone andrebbero collocate—se presenti in un
edificio adibito al culto—in un 'angolo di preghiera,' e quindi non
nell'aula dove si celebra.")

the Vatican's 2001 *Directory on Popular Piety and the Liturgy*, which quotes Nicaea II in adamantly encouraging veneration of images as an important part of popular piety, both at church and at home: images are to be "exposed in the holy churches of God, on their furnishings, vestments, on their walls, as well as in the homes of the faithful and in the streets."[3] The *Directory* also notes that the faithful honor images by "decorat[ing] them with flowers, lights, and jewels; they pay respect to them in various ways, carrying them in procession, hanging *ex votos* near them in thanksgiving; they place them in shrines in the fields and along the roads."[4] While the Nicaea directive is somewhat broad, and the latter statement not entirely prescriptive, both sketch out some of the space for possible exploration.

## Keeping Categories Clear: Liturgical, Devotional, and Historical Art

To begin to identify viable ways to integrate icons into the Western Church, it is necessary first to define the possible contexts in which they might be used. In his assessment of Church art, Denis McNamara makes a clear distinction between three different kinds of sacred art, noting that it was confusion of these that led to many of the problems with church art and architecture both prior to Vatican II and in the years since then. He notes that "for too long, Catholics (of the Latin rite in particular) have forgotten that liturgical art and architecture are themselves *part of the rite*, not merely a neutral setting for the liturgical

---

3. DPPL, no. 238, quoting Second Council of Nicaea, *Definitio de sacris imaginibus*.

4. Ibid., no. 239.

action."[5] In order to be properly used, each kind of image needs to maintain its own clear identity and be used in its own appropriate place.[6]

First, then, is the *liturgical image*. According to early Church tradition, the eucharistic liturgy we celebrate on earth is simultaneously a participatory "foretaste" of the heavenly liturgy described in Revelation. There we behold the new Jerusalem, its walls of gem-studded gold, full of light. Angels and saints in vestments praise God with incense around a throne. The Lamb is worshiped by twenty-four crowned elders and by countless multitudes wearing white robes, palm branches in their hands. Cries of "Holy, holy, holy is the Lord God of hosts," and "Salvation belongs to our God who sits on the throne, and to the Lamb!" echo from the mouths of the saints.[7] Authentic liturgical images, therefore, have the role of making this heavenly liturgy visible and sacramentally present to those on earth, aiding comprehension of the fuller reality of what is happening, and modeling behavior.[8] They are a source of anamnetic remembrance even as they also are part of eschatological anticipation during the liturgy.[9] Thus the "unified whole representing the heavenly liturgy" is the art that belongs

5. McNamara, *Catholic Church Architecture*, 13.

6. Denis R. McNamara, "Image as Sacrament: Rediscovering Liturgical Art," in *Sacrosanctum Concilium and the Reform of the Liturgy*, ed. Kenneth D. Whitehead (Chicago: University of Scranton Press, 2009), 61; McNamara, *Catholic Church Architecture*, 155–65.

7. McNamara, "Image as Sacrament," 61–62; cf. McNamara, *Catholic Church Architecture*, 11, 15–16, 71–81; SC 8; GIRM, no. 318.

8. McNamara, *Catholic Church Architecture*, 16, quoting SC 122: "The Second Vatican Council asked that liturgical art and architecture be composed of the 'signs and symbols of heavenly realities.'"

9. McNamara, *Catholic Church Architecture*, 143.

*Liturgical art makes visible the heavenly reality being celebrated. In spaces meant for celebrating the Eucharist, this could include eschatological imagery from the wedding feast of the Lamb. (Great Hall [formerly the abbey church] at Saint John's University, Collegeville, MN.)*

in the sanctuary; these images "are fundamentally public and intimately intertwined with the solemn and public prayer of the Church."[10] This kind of image is trying to depict a heavenly sort of reality so that people can imagine it and begin to understand their own active participation in it while at Eucharist. Thus McNamara argues, "In addition to being complete and theologically accurate, liturgical art must be naturalistic enough to be legible, abstract enough to be universal, and idealized enough to be eschatological."[11] These images reveal a deified human reality, just as they reveal both the divine and human natures

10. McNamara, "Image as Sacrament," 62.

11. McNamara, *Catholic Church Architecture*, 144–53; McNamara, "Image as Sacrament," 65, 67, 69: Liturgical art that is too naturalistic fails to raise the mind to heaven, while work that is too abstract is not human enough for us to see ourselves in it. For a good twentieth-century example of quality liturgical art reflecting these standards, see Felix B. Lieftuchter's murals in the Cathedral of St. Joseph in Wheeling, West Virginia (image: *Catholic Church Architecture*, 75). As McNamara notes, such quality liturgical art "is not a distraction from the liturgy. It *is* the liturgy." "Image as Sacrament," 67.

of Christ.[12] Until the entrance of modern art in the mid-twentieth century, this iconographic scheme was common in Christian churches.[13]

Next is the *devotional image*, which we have discussed in earlier chapters. Per *Sacrosanctum Concilium* and other Church documents issued since Vatican II, devotional art is "for veneration which is fundamentally private and associated with individual piety, or . . . [perhaps] associated with para-liturgical events."[14] These images support the prayer life that ought to come from and lead back to liturgical worship, but they are not primarily liturgical, as they do not depict the heavenly liturgy on earth. Typically images of Jesus, Mary, angels, and the saints, they tend to find their proper place in separate spaces not in competition with the altar and art of the sanctuary, which reflects the primary importance of liturgy.[15]

Third is the *historical image*, depicting scenes from the life of Christ or Church history. These images may be didactic or honorary, and may perhaps warrant meditation, but they are less connected with the liturgy itself. Generally speaking, because they depict narrative events, historical images tend to be less likely to evoke awe or personal devotion.

12. McNamara, "Image as Sacrament," 59; cf. Busi, *Il segno de Giona*, 31–32, on the importance of human images maintaining the proper theology of the incarnation.

13. McNamara, "Image as Sacrament," 62. From this perspective, it is a tragedy that when the Church embraced modern art within its spaces, many times imagery adequately depicting the heavenly aspect of the liturgy was lost.

14. Ibid., 63. SC 125 notes that devotional images for veneration should be kept, but their number and prominence moderated so as not to create confusion among the faithful. Liturgy is primary worship.

15. Ibid.

While lines may get blurred in regard to images connected with the passion, generally historical images are of tertiary importance, behind liturgical and devotional art.[16] While including stained-glass windows and murals, their proper location often tends to be outside the sanctuary.

### The Icon as Liturgical Image

In terms of the role of the icon, it could function as any of these three kinds of images. In relation to McNamara's standards for liturgical art, the icon anticipates heavenly realities while sacramentally making present what otherwise would be invisible.[17] Icons balance recognizable, realistic forms with stylization and idealization. They depict characteristics of both the human and the divine. Given this nature of the form, McNamara considers icons to be particularly suitable as liturgical art.[18] Certainly within the sanctuary, a great host of saints and angels visibly present can help evoke the celestial celebration in which we participate at Mass. We need to be aware of the communion of saints.[19] Nevertheless, when considering placement of images of saints within the sanctuary, a delicate balance

16. McNamara, "Image as Sacrament," 63. A crucifix over the altar, while depicting the passion, also makes visible what is happening during the liturgy on the altar and so is not merely a didactic historical image. The Stations of the Cross, while not necessarily the main focus while at the eucharistic liturgy as it occurs, are present during worship and depict aspects of the paschal mystery in which the assembly participates.

17. Ibid., 66, 70.

18. Ibid., 70.

19. BLS, no. 135: "Reflecting the awareness of the Communion of Saints, the practice of incorporating symbols of the Trinity and images of Christ, the Blessed Mother, the angels, and the saints into

must be struck such that the congregation can experience their presence as part of a shared liturgical reality and not simply as a collection of images for private devotion placed in a public space.[20] Large-scale images are more likely to inspire awe and a sense of the greater reality shared in liturgy, while smaller images invite the more intimate exchange of devotional prayer. Practically speaking, depending on the space in which it is placed, the panel icon may be too small to bring to life the imagery of the Mass of the book of Revelation for the full community. Large icons in a smaller chapel space, however, can convey this kind of reality effectively.[21] For most churches wishing to incorporate icons as liturgical art, large-scale fresco cycles, including iconic images such as *Christ Pantokrator* surrounded by saints, likely would be more appropriate.

While not a typical panel icon, a processional crucifix or the crucifix near the altar also poses a possibility for an icon in the Western Church. Intended to "[call] to mind for the faithful the saving Passion of the Lord," the crucifix near the altar should be large enough to be seen by the congre-

---

the design of a church creates a source of devotion and prayer . . . and should be a part of the design of the church." Cf. SC 8.

20. Cf. GIRM, no. 318. If statues are to be used in the sanctuary or nave as signs of the communion of saints present in the liturgical celebration, it may be helpful to have them situated amply high above the people rather than at eye level. In another, more private setting, placing statues at eye level can facilitate the personal kind of interaction conducive to appropriate devotional prayer. Practical concerns regarding access for cleaning also bear consideration. Brubaker, "The Sacred Image," 15, notes that even in iconoclastic times, Emperors Michael II and Theophilos wrote to Louis the Pious that images placed up higher might remain, "so that painting might fulfill [its didactic] purpose of writing."

21. Busi, *Il segno de Giona*, 95.

*Large icons can function as liturgical images in a small chapel space. (Icons by the hand of Gianluca Busi. Private chapel of Cardinal Carlo Caffarra, Villa Revedin, Bologna, Italy.)*

gation and may remain in position even outside Mass.[22] Since at least the thirteenth century, crucifixes painted in the Byzantine icon tradition have been part of the Catholic Church, particularly in Italy, and often have included images of saints as well.[23] Whether Christ is depicted as being more alive or as dead, the clarity of the iconic style in a crucifix provides a powerful image for liturgical or devotional contemplation of the Body of Christ and the paschal mystery present in the eucharistic celebration. The beloved San Damiano crucifix that spoke to St. Francis is a reminder of how important this kind of liturgical image can be.[24]

22. Cf. GIRM, no. 308.

23. Kristen Van Ausdall, "Communicating with the Host: Imagery and Eucharistic Contact in Late Medieval and Early Renaissance Italy," in *Push Me, Pull You: Imaginative and Emotional Interaction in Late Medieval and Renaissance Art*, vol. 1, ed. Sarah Blick and Laura D. Gelfand (Boston: Brill, 2011), 458n27.

24. Ibid., 461.

Another way to use icons liturgically is the display or procession of festal icons. In the Eastern tradition, worshipers greet the icon of the day on a stand often located just inside the nave of the church. While not necessarily depicting the literal particulars of the celestial worship of the book of Revelation, the festal icon does reflect the earthly liturgy connected with that of heaven as celebrated in the context of the liturgical year, either making visible the mystery of the feast itself, such as the incarnation, Palm Sunday, or the Transfiguration, or depicting the particular saint celebrated each day. Given this connection with the liturgy, this kind of icon could be considered appropriate for use in a Latin Rite Catholic Church as well.[25] Some level of care would need to be taken, however, in choosing how to present it. Are people expected to venerate such an icon? Should they light candles in front of it? Placing a festal icon near the entrance of the church makes sense in that its reference to the particular liturgical day prepares the community to enter into the sacred time that is liturgy.[26] Most Catholic churches renovated since Vatican II locate the baptistery close to the entrance as a sign of how we enter the Church through baptism. If situated nearby, a festal icon ought not to compete with this sign of the

25. Cf. BLS, no. 137, regarding spaces for an image of the day. It also may be appropriate to display icons of scenes from the life of Jesus correlating with the Sunday readings. Even if not depicting a feast *per se* (and technically representing a "historical image"), used in this way, they orient us toward liturgical time and so can function as liturgical images.

26. BLS, no. 98: "Well-placed religious art can facilitate the spiritual transition as people move to a sense of communal worship."

Church's sacramental life but complement it.[27] Flowers or a single candle before a festal image could be an appropriate simple form of honor. Churches choosing to engage practices more Eastern in flavor might include a space for members of the congregation to light small candles before this kind of icon. Another possibility would be to process such an icon into the church along with the Book of the Gospels, candles, and a processional cross at the beginning of the liturgy and to place it in an honorable place, perhaps near the ambo. This kind of festal icon then could help make visible the Word being proclaimed.

### Icons as Devotional Images

While festal icons and some *vita* icons[28] of saints also could be considered historical images, serving primarily a didactic purpose, by and large most icons probably are best categorized as devotional images, inviting more private personal prayer and veneration. Like the liturgical image, both historical and devotional icons are also sacramental "bearers of presence," making present some aspect of the mystery of the incarnation.[29] In this way, icons differ from some other kinds of devotional images, though as we have seen in the West, other kinds of devotional art can also share in this sacramental nature; not every devotional piece of art has to be an icon. By cultivating connection with the communion of saints, praying

27. Ibid., nos. 131, 143.

28. The *vita* icon is a way of honoring a saint by including hagiographical images of his or her life around a central image. See Nancy Patterson Ševčenko, "The 'Vita' Icon and the Painter as Hagiographer," *Dumbarton Oaks Papers* 53 (1999).

29. McNamara, "Image as Sacrament," 58–59.

with icons in a devotional context prepares the faithful to recognize the presence of their heavenly companions when they do arrive to participate in liturgy. According to Nicaea II, "The more often we gaze on these images, the quicker we who behold them are led back to their prototypes in memory and in hope."[30] In prayer with these models of holiness, we are drawn toward the beauty of goodness. Praying with images of Christ likewise can nurture an emotional connection and increase love for him. As John Paul II writes, "Art can represent the form, the effigy of God's human face and lead the one who contemplates it to the ineffable mystery of God made man for our salvation."[31] Whatever the form used, personal, private prayer is imperative preparation for a fruitful sacramental life; icons can help elicit the practice.

Church documents recommend that spaces be arranged to facilitate devotional prayer that does not distract from the liturgy.[32] This could include some spaces separate from the nave and the sanctuary, such as alcoves or small side chapels with statues or icons.[33] To invite veneration of icons in this kind of setting, clear accessibility, balanced with a level of relative privacy, seems ideal. A place to sit, kneel, or stand allows for some flexibility in prayer form, as well

30. Second Council of Nicaea, cited in the "Order for the Blessing of Images for Public Veneration by the Faithful," in *Book of Blessings* (Collegeville, MN: Liturgical Press, 1989), chap. 36, 465n27.

31. DS, no. 9.

32. BLS, no. 131, cf. SC 13; CCC, no. 2691: "For personal prayer, [the church building can provide] a 'prayer corner' with the Sacred Scriptures and icons, in order [that parishioners may] be there, in secret, before our Father."

33. BLS, no. 137.

as the possibility of lighting vo-
tive candles.[34] Moreover, in the
Eastern tradition, icons are meant
to be touched. When sealed with
protective layers of oil and var-
nish, icons should be able to
withstand some level of interac-
tion of this sort, though a number
of Orthodox churches do use
icon stands that enclose them in
a protective case. This certainly
could be an option in our West-
ern use of icons, but it seems that,
if possible, we should not create
unnecessary barriers between
the faithful and icons. If security
concerns are an issue, this can be
addressed by hidden cables that
run through the back of an icon
and lock into a stable base.

*A small chapel can be arranged to
invite devotional prayer with icons.
(Saint John's Abbey Guesthouse,
Collegeville, MN.)*

Given how saturated today's culture is with visual stimuli,
special care is needed in creating a devotional space to pray
with an icon. Every day, advertising in all its various forms
cries out for attention; video is a primary form of entertain-
ment; most basic communication devices now are visual as
well as auditory tools. The icon is different. It is not just
another image, and, in fact, it counters the "depersonaliza-

---

34. The relatively recent appearance of electric votive candles is
ridiculous in light of Vatican II's penchant for authentic materials
that are real signs. Certainly we can be creative enough to provide
spaces for votive lights that respect both authenticity and safety
concerns regarding fires.

tion and degrading effects" of some of these other kinds of images.[35] The icon teaches us how to see again with recognition and appreciation for the presence of the sacred. Those entering a prayer chapel to pray with an icon need to know by its context that they are in a different kind of space. Gentle, well-directed lighting can help provide focus and a level of privacy. Limiting presentation to only one or maybe several images at a time can settle the attention. While most Eastern Christians are quite at ease entering a church surrounded by frescoes and rows upon rows of icons, for many Latin Rite Catholics, immersing in such sensory overload can be overwhelming. Moreover, while space of that nature may be appropriate for liturgical prayer, during devotional prayer, the focus is more on the prayer of the individual who can give full attention to only one thing at a time. When semiprivate spaces are created for devotional prayer with icons, it sets an example for how people might also use sacred images for prayer in their homes.

As to the kind of images depicted in devotional icons to be displayed in the church building, *Built of Living Stones* advises: "It is particularly desirable that a significant image of the patron of the church be fittingly displayed, as well as an image of Mary, the Mother of God."[36] Saints or images of particular meaning to the community also are appropriate, and it is important that the saints chosen reflect the actual piety of the community.[37] As Raúl Gómez writes, "Activities arising from popular piety are . . . expressions

35. DS, no. 11.
36. BLS, no. 138.
37. Ibid. Note also DPPL, no. 243: "Popular piety encourages sacred images which reflect the characteristics of particular cultures; realistic representations in which the saints are clearly identifiable,

of culture and contribute to the construction of identity as well as of meaning for a particular people."[38] Another possibility for using devotional icons is to rotate images as appropriate through the liturgical year.[39]

A thornier question is whether it is advisable to place an icon of Christ in a Blessed Sacrament chapel near the tabernacle. Church documents do not appear to give clear direction. According to the *General Instruction*, the place of the tabernacle should be "in a part of the church that is truly noble, prominent, conspicuous, worthily decorated, and suitable for prayer"; a candle or oil lamp should be kept lit nearby "to indicate the presence of Christ and honor it."[40] *Built of Living Stones* directs:

> The place of reservation should be a space that is dedicated to Christ present in the Eucharist and that is designed so that the attention of the one praying there is drawn to the tabernacle that houses the presence of the Lord. Iconography can be chosen from the rich treasury of symbolism that is associated with the Eucharist.[41]

While the candle symbolizes the presence of Christ, the presence of Christ in the reserved Eucharist is a rather abstract notion that is challenging enough to belief in any era, central as it may be. Given the "symbolic illiteracy" of many people today, perhaps an image of Christ would

---

or which evidently depict specific junctures in human life: birth, suffering, marriage, work, death."

38. Gómez, "Veneration of the Saints and *Beati*," 121.

39. BLS, no. 137.

40. GIRM, nos. 314, 316; cf. *Code of Canon Law*, c. 938, par. 2.

41. BLS, no. 73.

aid fuller comprehension of his presence. This is the power of mental association invoked in the directive to have a crucifix placed near the altar.[42] Certainly a high-quality icon adds beauty and is suitable for prayer; "iconography," referring here more broadly to "imagery," is permitted. At the same time, placement of a Christ icon in this context would have to be so paired with the tabernacle that any honor given to the presence of Christ in the icon would be seen as going immediately toward the presence of Christ in the Eucharist and ultimately beyond even that to Christ "uncircumscribed." While the image and the larger reality need to remain distinct and identifiable, to separate them too much in this context would seem to set up a competition between what is a canonic sacrament of the Church and what is, comparatively, a sacramental. Is attention drawn to Christ in the tabernacle or away from him? While the practice of placing an image of Christ nearby seems a bit risky, a very high-quality icon, placed with immense care, could be a great aid to building devotion to Christ present in the Eucharist.

### Icons as Historical Images

According to McNamara's schema of liturgical, devotional, and historical images, the latter are tertiary in importance.[43] Because they are primarily educational or honorary in purpose, historical images tend to be more appropriate outside the sanctuary, nave, and devotional chapels of the church. They perhaps are best displayed

---

42. GIRM, no. 308; cf. Van Ausdall, "Communicating with the Host," 458–61.

43. McNamara, "Image as Sacrament," 63.

then, as mentioned above with festal icons, in the gathering area, in transitional spaces, or perhaps in a church hall. While historical images of other kinds might appropriately be used purely as decoration, in light of the particularly sacramental nature of icons, it would be important to consider how to honor a historical icon appropriately if it is not situated in a naturally fitting liturgical or devotional context. The simple honor of flowers or a single candle may be suitable, or perhaps placement within a kind of space that marks the image as something special.

### Integrating Icons amid Other Kinds of Sacred Art

According to John Paul II, "Authentic Christian art is that which, through sensible perception, gives the intuition that the Lord is present in his Church, that the events of salvation history give meaning and orientation to our life, that the glory that is promised us already transforms our existence."[44] All "authentic Christian art" technically can do this—not only the icon. Yet, as we have explored, it seems proper to give, to icons in particular, the veneration they are due in light of their Eastern tradition, even if that means facilitating different forms of veneration than might be common in the Orthodox Church. So in a church open to all different kinds of sacred art, how are icons to be treated? Thus far we have seen some of the ways icons can function as liturgical, devotional, or historical art. In a church using solely icons, their difference from other kinds of art is not so problematic. Even without additional catechesis, if presented well, the icons' context alone may provide enough guidance to a congregation so that they sense intuitively how to

44. DS, no. 11.

interact with them. Unity of the artistic program provides a coherence that can be quite beautiful and spiritually nourishing. The reality of most Catholic parishes, however, is somewhat heterogeneous, and multiple styles of sacred art may be warranted, especially if reflecting the piety and character of a diverse congregation. In this situation, careful planning and catechesis are key. Generally speaking, presuming a community has determined the function the icon is to play, it would seem best to provide icons their own space such that interaction with them need not be confused with that appropriate for other kinds of art. To "read" an icon properly, people must use particular "lenses" that allow one to enter into a spiritual world where inverse perspective, layering light, and a particular stylization point to something holy. If the icon is placed next to a piece that uses traditional depth perspective or three-dimensionality, some aspects of the icon may be misperceived as distortion rather than reality and may not be as appreciated. Likewise, creating a direct comparison with a piece of a more naturalistic style may cause the icon to be seen as being too formal or inaccessible. Yet, despite a few possible difficulties, in some cases, integrating multiple forms of art including icons within one space could be effective. The key seems to be to provide the necessary context for each piece suggesting appropriate interaction.

### Icons and Catechesis

Whatever the choices made for presenting icons within a Western Rite church, some level of catechesis seems imperative. To appreciate the beauty of an icon properly, one must know what it is and how it is created. Certainly something of the spirituality of the iconographer comes through

in the image, and the holiness of Christ or the saint depicted is attractive, but these are effective only if the icon created is a quality work of true beauty.[45] Particularly now, when in so many ways we have forgotten how to see, when poor iconography and mass-produced mounted prints pass as quality work in Western churches, it is important that people be taught what makes an icon beautiful, authentic, and worthy of veneration. What are the Eastern standards we should hope to see in terms of blending, brushwork, calligraphy, and overall proportion? Does the work adequately depict the truths of belief? Is it capable of "bearing the weight" of devotion and the transcendent mystery of God? True beauty "is a key to mystery and a call to transcendence. . . . It stirs that hidden nostalgia for God."[46] In the classic Western sense of beauty, "an object is beautiful when it most clearly and fully reveals its ontological reality."[47] In other words, it shows clearly what it truly is.

45. Busi, *Il segno de Giona*, 35, notes that icons look beautiful to the degree that they convey the spiritual image of the divinized figure and convey the "beauty that saves." My translation: "The icon is beautiful that generates interior beauty." ("L'icone è bellezza che genera bellezza interior.") Russian master iconographer Ksenia Pokrovsky believed "the church doesn't need great art; it needs art that's good enough." Circumstances vary, and as with religious kitsch in which a believer can recognize and connect with the true holiness of the one depicted, sometimes a piece of sacred art can be whatever the viewer needs it to be, regardless of its technical quality. Even a simple sketch of an icon of a saint on paper can be sufficient, if the beholder needs it to be a true icon for prayer. Thus at some level artistic standards can be irrelevant. Personal correspondence with Pokrovsky assistant Marek Czarnecki, October, 23, 2012.

46. LA, no. 16.

47. McNamara, *Catholic Church Architecture*, 21.

Aquinas says beauty is marked by *integritas*, *consonantia*, and *claritas*: wholeness, proportionality, and clarity of a thing's inner being.[48] With catechesis, people can be taught to appreciate how a quality icon radiates the truth of Christian belief, the beauty of holiness, and the wonder of a world redeemed and present right in our midst. They can be taught the difference between idolatry and proper veneration. They can be led to appreciate how the Eastern Church has maintained some aspects of the Christian tradition that rightly are available to all.

Icons themselves can be an aid to catechesis of other kinds. The use of icons in the home can be a great complement to their usage in churches, particularly if icons are used to honor baptisms, confirmations, weddings, and personal patron saints. In this way, the faithful are given a visual reminder that one's personal faith journey is connected with that of holy people already involved in the great story of salvation. Icons also are a great tool for theological study, as they

> express "through colors" a theology of particular profundity and density. The truths of the faith come to be seen through a presentation tied to the patristic tradition and the iconography and preserve a strong connection with the most genuine tradition of the Church. Icons thus become a vehicle of transmission of concepts now lost as a way of doing theology and catechesis often missing in teaching.[49]

48. Ibid., 24.

49. Busi, *Il segno de Giona*, 67, my translation. The original is as follows: "L'icona puó opportunamente esprimere 'attraverso i colori' una teologia di particolare profundità e densità. Le verità de

Particularly in the West, theology has privileged the written word, both in its teaching and liturgy. Yet images have their own particular power to communicate truth; their perceptible beauty sometimes can be more attractive and speak more clearly than the difficult twists and turns of reasoned theological argument. As John Paul II writes, the Church needs art to communicate the message of Christ: "Art must make perceptible, and as far as possible attractive, the world of the spirit, of the invisible, of God. It must therefore translate into meaningful terms that which is in itself ineffable. . . . It does so without emptying the message itself of its transcendent value and its aura of mystery."[50] Precisely because images do not define terms as precisely as writing does, they have the power to respect the *mystery* of God and the Church without reducing it to something we can comprehend completely. This is a great theme of Vatican II. Busi sees religious communities in particular as having the potential to alert the world to the great possibilities of icons as transmitters of "a theology that is rigorous and at the same time dense in spirituality."[51]

Beyond catechesis of the faithful, Busi suggests that icons are also a powerful tool for pre-evangelization, with the capacity to touch those not always reached by regular pastoral care, especially those who feel themselves cut off

---

fede vengono esposte attraverso una esposizione legata alla patristica e alla iconografia, e conservano un aggancio forte con la tradizione piu genuina della Chiesa. Le icone diventano cosi un veicolo di trasmissione di concetti ormai smarriti, da un modo di fare teologia e catechesi spesso disperso nel didascalico e nell'anedotico."

50. LA, no. 12.

51. Busi, *Il segno de Giona*, 68, my translation. The original reads: "una teologia rigorosa e nello stesso tempo densa di spiritualità."

from the life of the Church.[52] Such pre-evangelization has been aided by many public exhibitions of icons, often organized by prestigious institutions.[53] While he raises the concern that icons ultimately should not become a replacement for the community and liturgical life of the Church, they can be a spiritual meeting point offered by the Church:

> Many people far from the paths of ecclesial life recover a hint of the "spiritual" by buying icons and placing them in their homes. In a context of profound desacralization of experience and of environments, often it is the icon itself that can weave a fine line between secularization and spirituality, where other tools do not seem to be present that could permit the meeting of these sides. . . . This kind of person, feeling a sympathy and closeness with a sacramental like the icon, asserts the need to identify a way of approaching the sacred. . . . [Yet] it takes patience and discernment to evaluate on what basis and with what connections images can be introduced in worship, so that they do not encourage partial forms of membership in the Church.[54]

52. Ibid., 59, 67, 69, my translation: "The split between the Gospel and life has moreover created a widespread unease regarding full participation in the Eucharist, and many people have felt an attraction to icons that have communicated sacredness without requiring membership in the Church." ("La spaccatura fra il Vangel e la vita ha poi creato un diffuse disagio per la participazione piena all'Eucaristia, e molti fedeli hanno sentito una attrazione per le icone che comunicavano sacralità senza richiedere appartenenza ecclesiale.")

53. Ibid., 67.

54. Ibid., 67, 69, my translation. ("Molte persone lontane da percorsi di vita ecclesiale ritrovano un accenno allo 'spirituale' acquistando icone e custodendole nelle case. In un contesto di profunda desacralizzazione dei vissuti e degli ambienti, spesso e proprio l'icona a tessere un filo sottile fra secolarizzazione e spiri-

Certainly beauty's attractiveness makes icons a natural catechetical tool for drawing people closer to theological truth. Made more widely available and shared with wisdom, authentic icons have the power to invite people deeper into the life of the Church.

As the Western Church continues to explore ways to promote icons, one other necessary form of catechesis is quality, ongoing training for Catholic iconographers. Basic artistic skill and training are important, as is the theological and spiritual formation required for artists to become adequate vehicles for the sacred. Some appropriation of traditional Eastern standards for moral behavior and spirituality of iconographers appears fitting for Western usage as well.[55] In time, perhaps "Catholic icons" also will go through some sort of local review process akin to that in the Orthodox Church to determine which images are aesthetically and spiritually sufficient for liturgical usage. For now, the best Catholic iconographers study Eastern techniques as they develop images of Western saints and feasts. It remains to be seen which will emerge as the highest quality prototypes to be woven into the tradition.

---

tualita, laddove non sembrano quasi piu presenti strumenti che possano permettere l'incontro di questi aspetti. . . . Questa categoria di persone, sente simpatia e vicinanza per un sacramentale come l'icona, e ne rivendica la necessità per individuare un percorso di avvicinamento al sacro . . . occorre pazienza e discernimento per valutare a quale titolo e con quali rapporti le immagini possano essere introdotte nel culto, affinchè non incoraggino forme di appartenenza ecclesiale parziale.")

55. Irina Yazykova, *Hidden and Triumphant: The Underground Struggle to Save Russian Iconography*, trans. Paul Grenier (Brewster, MA: Paraclete Press, 2010), 37–38.

**Chapter 6**

# Ecumenical Implications

While the Western Church has its own tradition of holy images, when Catholics and Protestants embrace icons, something ecumenical is happening. More and more today, Catholics are including icons in their homes, schools, and church spaces. Churches of the Anglican Communion are commissioning icons. People of Protestant faiths are learning to write icons, and "Western saints" have begun to appear. What is the current that is driving Western interest in icons, and what are the implications when non-Orthodox Christians get involved with these sacred images? Because the icon tradition is so rooted in the Eastern Church, the creation and use of icons is a grassroots ecumenical issue. It is true that people of the Orthodox Church sometimes can be protective of their tradition. Yet, while such limitation may be vexing to other Christians, too often ignorance and disregard of the Eastern tradition have led others to create or to interact with icons in ways that are either confusing or distressing to Orthodox believers. Who is responsible for addressing the issue when no real standards guide

the production and dissemination of new images and the theology depicted appears distorted? If no other authority steps in to attend to abuses, the Orthodox have reason to be protective. Yet some interaction seems necessary. If Catholics and Protestants are yearning for icons and are going to paint or use them anyway, who better than the Orthodox can teach them properly what an icon is? In an ecumenical time, where a "dialogue of love" must precede any "dialogue of truth,"[1] sharing in the beauty and truth of icons seems a remarkable place to start. Perhaps here, reflecting with humility and respect for these visible elements of the faith, the beginning of mutual understanding can be born.

## Catholic Use of Icons and Relations with the Orthodox Church

Catholics tend to be fairly optimistic about ecumenical efforts toward unity with the Orthodox Church. Theologically, we have much in common, and the list of official obstacles to full reunion is fairly short. The Orthodox, however, tend to feel a profound sense of separation in relation to Roman Catholicism. Old political wounds, including the 1204 Latin sack of Constantinople and perceived Catholic proselytism in Eastern lands, combine with cultural differences to pose a greater challenge to ecumenical unity than Catholics often think.[2] Eastern Catholic hieromonk Maximos

1. Angelo Maffeis, *Ecumenical Dialogue*, trans. Lorelei F. Fuchs (Collegeville, MN: Liturgical Press, 2005), 41.
2. Maximos Davies, "What Divides Orthodox and Catholics?," *America* 197, no. 18 (December 3, 2007): 15–16; Bernard Leeming, "Orthodox-Catholic Relations" in *Re-discovering Eastern Christendom*, ed. A. H. Armstrong and E. J. B. Fry (London: Darton, Longman &

Davies writes, "Questions of ecclesial culture tend to be underweighted in ecumenical dialogue."[3] Issues ranging from attitudes toward liturgy to principles of governance differ between the Churches, contributing to a sense of two different worlds. Where Catholics tend toward privatization of prayer and personal devotion, Orthodox tend to share in communal asceticism (such as fasting) and publically shared devotion alongside their personal prayer life.[4] We can see these differences in how icons are used. Catholics may pray before an icon in a semiprivate side chapel or at home, nourishing individual devotion that prepares one for liturgy, but in the Orthodox Church, personal veneration of icons is first a public event that binds the community together.[5]

---

Todd, 1963), 22–23. In his 1959 *History of the Council of Florence*, Fr. Joseph Gill notes some of the historical issues that divide the Churches: in addition to the Crusaders' sack of Constantinople, Norman and French attempts at conquest, "the depredations of the Catalan Grand Company," introduction of Latin patriarchs and bishops in Eastern cities, Latin "contempt and ignorance of the Greek liturgical rite and the differences of ecclesiastical tradition" (including married and unmarried clergy, bearded and unbearded priests, and discipline in regard to fasts), among "dozens of other unimportant points," all have constituted cause for friction. See Joseph Gill, *History of the Council of Florence* (New York: Cambridge University Press, 1959, repr. 2011).

3. Davies, "What Divides Orthodox and Catholics?," 16.

4. Ibid.

5. Claire Maria Chambers, "The Common and the Holy: What Icons Teach Us about Performance," *Liturgy* 28, no. 1 (January 2013): 21. Chambers observes how personal veneration of icons at Orthodox liturgy strengthens the faith of the whole community: "That everyone, as a community, was watching everyone else enter into a space of personal devotion and relationship [with the icon] spoke of the icon's ability to fuse a universalizing faith with local

At the theological level, the mainstream Orthodox view toward ecumenism is that the fullness of the truth resides in the Orthodox Church, and that, ultimately, everyone must convert to Orthodoxy for true unity to occur. A smaller number of traditionalist believers consider members of all other Churches heretics whose sacraments are of no effect; seeing interaction with heresy as dangerous, they oppose all ecumenism.[6] Yet most Orthodox theologians are open to some level of dialogue, though historically they have differed in regard to what ecumenism means in terms of steps necessary to achieve unity.[7] Certainly efforts have been made, particularly since Vatican II's *Unitatis Redintegratio* (the Decree on Ecumenism) and

---

participation. . . . Not only does the icon fuse the universal and local, but the individual and communal."

6. John A. Jillions, "Three Orthodox Models of Christian Unity: Traditionalist, Mainstream, Prophetic," *International Journal for the Study of the Christian Church* 9, no. 4 (November 2009): 295–98. For more on ecumenical efforts between Catholics and the Orthodox, see Iakovos, archbishop of the Greek Orthodox Dioceses of North and South America, *That They Might Be One: Position Papers, Essays, Homilies, and Prayers on Christian Unity*, ed. Demetrios J. Constantelos (Brookline, MA: Holy Cross Orthodox Press, 2007); Anthimos VII, *Orthodox and Catholic Union: The Reply of the Holy Orthodox Church to Roman Catholic Overtures on Reunion and Ecumenism* (Seattle, WA: St. Nectarios Press, 1985); Constantine Cavarnos, *Ecumenism Examined* (Belmont, MA: Institute for Byzantine and Modern Greek Studies, 1996).

7. Jillions, "Three Orthodox Models of Christin Unity," 299–309: Some involved in ecumenical dialogue, such as Georges Florovsky (1893–1979), a founding member of the World Council of Churches, believe doctrinal agreement must precede any sacramental sharing. Others believe some level of sacramental sharing might be instrumental in leading to full doctrinal unity.

John Paul II's 1995 apostolic letter on the Eastern Churches, *Orientale Lumen*.[8] While it is true that obstacles exist, Davies writes, "In healing these divisions, especially those that exist on the cultural level, theologians and diplomats can do only so much. We spiritual ecumenists, faithful Christians, must do the rest."[9] Christian Link likens efforts toward ecumenical unity to a game: sometimes members of the Churches discuss the *rules* of the game, and sometimes members simply *play the game* of an ecumenical Church by living it.[10] Non-Orthodox work with icons is precisely this kind of grassroots ecumenism. For Catholics and Protestants who would learn from the Orthodox about icons, occasional encounter with those of a traditionalist stance can make interaction difficult. Orthodox writers abound, however, and many Orthodox believers are happy to speak about their faith tradition.

Because ecumenical work with the Orthodox Church can be so delicate, in order to foster greater trust, it seems imperative that Catholics and Protestants learn more about Eastern theology, and as much as possible, follow Orthodox

8. Second Vatican Council, *Unitatis Redintegratio* (hereafter UR), in Thomas F. Stransky and John B. Sheerin, *Doing the Truth in Charity: Statements of Pope Paul VI, Popes John Paul I, John Paul II, and the Secretariat for Promoting Christian Unity 1964–1980* (New York: Paulist Press, 1982), 17–33.

9. Davies, "What Divides Orthodox and Catholics?," 17; Maffeis, *Ecumenical Dialogue*, 90: "More than an oversimplified opposition of the grassroots to the higher levels, the ecumenical panorama must, therefore, be represented as a network of individuals who, in a way spontaneous or more institutionalized, with occasional or stable initiatives, commit themselves to promoting dialogue and unity among Christians."

10. Maffeis, *Ecumenical Dialogue*, 88.

standards when it comes to creating or propagating icons in the West. Thus far, this has not happened with any consistency. Icon-painting workbooks and workshops of varying quality are available, and no particular credentials are required of teachers. Of particular concern are the creations of Catholic artists who would use what appears to be the icon medium to do something other than the authentic work of a canonical icon. Two of the most well-known Catholic iconographers today are Robert Lentz and his student, William Hart McNichols. The grandson of emigrants from tsarist Russia, Lentz apprenticed with a master iconographer of the Greek school to learn technique. He was among the first to start painting icons of Western saints and was a modern pioneer in drawing Catholic and Protestant attention to icons.[11] His traditional-style work basically follows Eastern standards. Lentz, however, also uses the icon form to make art with themes of social concern. He has depicted people in icons who, honorable as they may be, have not yet been canonized saints, such as Dorothy Day and Thomas Merton, and some who likely never will be canonized, like Albert Einstein and Johann Sebastian Bach. Some of his icons depict theology the Catholic Church would not accept as orthodoxy; his icon of St. Brigid includes reference to the Irish pre-Christian goddess of the same name; his depiction of the Sacred Heart of Christ would hardly be recognizable as such were a title or expla-

11. "Biography," *Franciscan Icons by Robert Lentz*, posted June 19, 2012, http://robertlentzartwork.wordpress.com/, and *Trinity Religious Artwork and Icons*, https://www.trinitystores.com/store/artist/Robert-Lentz; Personal communication with iconographer Marek Czarnecki, December 19, 2012.

nation not provided.[12] McNichols and others have followed in their teacher's footsteps.[13] Despite this, the work of both artists is widespread.

What can be said of this kind of painting? Is it iconography at all? Though use of elements such as a frontal view, a simplified background, halos, inscriptions, and even some inverse perspective might suggest that these depictions are icons, they lack the theological worldview of the icon's Eastern roots. Traditionally, an icon depicts transfigured, deified reality. As moving as some of these images may be, portraying Christ behind a barbed-wire fence or showing the Immaculate Heart of Mary before a mushroom cloud does not qualify as a vision of heaven.[14] Images that reflect faulty theology or imply critique of the Church likewise do not depict a world already redeemed by Christ.[15] By McNamara's

12. See images at https://www.trinitystores.com/store/art-image /sts-brigid-and-darlughdach-kildare and https://www.trinity stores.com/store/art-image/sacred-heart. His "Celtic Trinity" likewise could be considered problematic to Catholic or Orthodox theology: https://www.trinitystores.com/store/art-image/celtic -trinity.

13. Among McNichols's work is an icon of Diana, Princess of Wales: *St. Andre Rublev Icons*, http://www.fatherbill.org/gallery .php?action=viewPicture&id=141&gall_id=21, 2008. Another odd "icon" depicts an enthroned John Coltrane with the Holy Spirit emerging as fire from his saxophone: "Saint John Coltrane Enthroned," Mark Dukes, *Fine Art America*, http://fineartamerica.com /featured/saint-john-coltrane-enthroned-mark-dukes.html.

14. Robert Lentz, "Christ of Maryknoll," https://www.trinity stores.com/store/art-image/christ-maryknoll; William Hart McNichols, "Triumph of the Immaculate Heart," http://www.father bill.org/gallery.php?action=viewPicture&id=205&gall_id=16.

15. It could be argued that traditional Orthodox icons of Christ crucified or the Mother of Sorrows are similarly troubling. Given,

standards, moreover, images that depict too much of an earthly perspective rather than heavenly reality are insufficient as liturgical art.[16] As John Paul II writes, "Sacred art must be outstanding for its ability to express adequately the mystery grasped in the fullness of the Church's faith."[17]

While the Orthodox Church would anathematize such images, the Catholic Church does not appear to have any coherent review process and has not stepped in at an official level to respond to this kind of work. Simply deciding that these are not icons *per se* but rather art with a social message does not appear sufficient. Because most Western Christians do not know the theological requirements of a true icon, it is, if not intentionally deceptive, at least confusing to use so many elements of this form to convey something different. Even if many people may not be familiar with icons, most sense intuitively that the icon form tends to suggest that whatever is depicted is considered hallowed. Certainly we need art with social critique, and the Church needs people in every age to hold it accountable, but to use the icon form to do this is an obfuscation and abuse of the role of iconography. Theology made visible tends to suggest that the beliefs depicted have been set and approved, but that is not always the case in this kind of Western icon. The

---

however, these images' integral, recognizable connection to the paschal mystery, they are seen as acceptable. Canonical icons of the crucifixion depict Christ in a kind of glory rather than in dire, bloody suffering. Sometimes John the Baptist is identified with the symbol of his martyrdom, holding his head on a platter, but because the icon is an image of heaven where all actually is whole, he also has his head attached to his neck!

16. McNamara, "Image as Sacrament," 60.

17. EE, no. 50.

icon must clarify reality, not obscure it. Moreover, as art that belongs to the Church, it is important that the icon proclaim in a recognizable manner what the Church teaches. When Mahmoud Zibawi writes that "Western influences have done more harm to Byzantine painting than have the Turks," he could be speaking perhaps as much of our own age as he is the Crusader and early modern period.[18] To rebuild trust between Roman Catholicism and Orthodoxy, basic respect for the art form so cherished by the Eastern Church is critical. As Vatican II's 1964 *Unitatis Redintegratio* states,

> In ecumenical work, Catholics assuredly must be concerned for their separated brethren. . . . [T]heir primary duty is to make a careful and honest appraisal of whatever needs to be renewed and done in the Catholic household itself, in order that its life may bear witness more clearly and faithfully to the teachings and institutions which have been handed down from Christ through the Apostles. (UR 1)[19]

While some might claim artistic right to do whatever they please in the name of creativity, or perhaps even see it as an expression of personal conscience, when it comes to icons, the Catholic Church needs grassroots ecumenical efforts to start with attention to the wider effects of our own behavior.[20]

18. Mahmoud Zibawi, *The Icon: Its Meaning and History* (Collegeville, MN: Liturgical Press, 1993), 148.
19. This translation of UR is taken from Stransky and Sheerin, *Doing the Truth in Charity*, 22.
20. Davies, "What Divides Orthodox and Catholics?," 17.

Beyond the sphere of icons alone, Catholics working toward greater unity with the Orthodox Church also can help rebuild a common culture. It is part of coming to "understand the outlook of our separated brethren" (UR 9).[21] Of particular importance in this regard are the Eastern Catholic Churches (UR 17; cf. *Orientalium Ecclesiarum* [hereafter OE] 24).[22] While making use of their own Eastern liturgical rites and customs, which tend to parallel those of the local Orthodox Church, these twenty-one Churches

---

21. Translation of UR 17 from Stransky and Sheerin, *Doing the Truth in Charity*, 25. See also UR 15 in Stransky and Sheerin, *Doing the Truth in Charity*, 28: "Everyone should realize that it is of supreme importance to understand, venerate, preserve, and foster the rich liturgical and spiritual heritage of the Eastern Churches in order faithfully to preserve the fullness of Christian tradition, and to bring about reconciliation between Eastern and Western Christians."

22. Ibid., 34. See also John Madey, *Ecumenism, Ecumenical Movement and Eastern Churches* (Kerala, India: Oriental Institute of Religious Studies Publications, 1987); E. R. Hambye, "Problems and Prospects of Ecumenism in the Eastern Catholic Churches," in *Oriental Churches: Theological Dimensions*, ed. Xavier Koodapuzna (Kerala, India: Oriental Institute of Religious Studies Publications, 1988), 242–49. As noted in OL 21, relations between the Eastern Catholic Churches and the Orthodox have often been tumultuous, even as the former have also found misunderstanding among Catholics of the Roman Rite: "These Churches carry a tragic wound, for they are still kept from full communion with the Eastern Orthodox Churches despite sharing in the heritage of their fathers. . . . Conversion is also required of the Latin Church, that she may respect and fully appreciate the dignity of Eastern Churches and accept gratefully the spiritual treasures of which the Eastern Catholic Churches are the bearers, to the benefit of the entire catholic communion; that she may show concretely . . . how much she esteems and admires the Christian East and how essential she considers its contribution to the full realization of the Church's universality."

remain in communion with Rome. Although the Western Catholic Church likely will continue to look different from its Eastern sisters for a long time to come,[23] greater cultural sharing in practices that are ultimately of common heritage to both Churches can only help build relationship. The art of the icons is such shared patrimony of East and West: it is a "hope, and even a pledge . . . of communion in faith and celebration."[24]

## *Catholic Use of Icons and Relations with Protestants*

If greater use of icons naturally implies some kind of ecumenical dialogue with Eastern Orthodoxy, it may also affect relationships with various Protestant denominations and members of the Anglican Communion. While Protestants of various backgrounds have shown increasing interest in icons more recently, both the Lutheran and Reformed branches of Protestantism have a history of rocky relationship with images. Would more canonical Catholic use of icons distance us from or draw us closer to these Churches? How can iconography be shared across these denominational lines?

At the time of the Reformation, Protestant mistrust of images in many ways was a response to pre-Reformation overemphasis on the value of images to the exclusion of quality preaching and teaching of the Word; sixteenth-century Bavarian humanist Jakob Ziegler argued that the image conveyed truth better than did writing, including

---

23. On the term "sister churches," see Maximos Aghiorgoussis, *In the Image of God* (Brookline, MA: Holy Cross Orthodox Press, 1999), 153–95.

24. EE, no. 50.

even Scripture.[25] In response, Protestants tended to develop a greater stress on the value of hearing, seeing, and preaching the Word, rather than seeing images.[26] Objects and images were perceived as being "more sensual than language" and possibly dangerous to virtue.[27] For these reasons, among the Protestant churches that retained decorative elements in their worship spaces, many gave pride of place to biblical inscriptions on their walls rather than to images.[28]

*Many Protestant churches privilege biblical inscriptions as decorative elements. (Gosau, Upper Austria.)*

Generally speaking, in both liturgy and worship space, Luther and his followers were more open to visual elements than were other Protestants. Coming from a nomi-

25. Sergiusz Michalski, *The Reformation and the Visual Arts* (New York: Routledge, 1993), 192; R. Kevin Seasoltz, *A Sense of the Sacred* (New York: Continuum, 2005), 170.

26. Michalski, *The Reformation and the Visual Arts*, 38; David Morgan, *Icons of American Protestantism: The Art of Warner Sallman* (New Haven, CT: Yale University Press, 1996), 4; David Freedberg, *The Power of Images: Studies in the History and Theory of Response* (Chicago: University of Chicago Press, 1989), 400; Seasoltz, *A Sense of the Sacred*, 164, 169–70, 178; Belting, *Likeness and Presence*, 466.

27. Colleen McDannell, *Material Christianity* (New Haven, CT: Yale University Press, 1995), 13.

28. Michalski, *The Reformation and the Visual Arts*, 70.

nalist perspective, Luther saw the image as a "conventional, relative sign," not intrinsically part of the reality it represented.[29] His primary concern with images related to his beliefs about justification; he did not want Christians to seek salvation through interaction with images but through faith alone. Clearly much Protestant violence against images during the Reformation was connected with the indulgences the faithful could gain from praying before them.[30] Regarding the saints, while Luther gradually became less opposed to their images, he relativized their value as saints became models not of good deeds but of faith.[31] He also was anxious about the "social costs of art" and believed the needs of the poor should be served first.[32] For all these concerns, however, Luther denounced the use of violent iconoclasm, advocating instead orderly removal of images that might become idols.[33] He supported the use of historical art and some devotional images for their pedagogical value, particularly encouraging illustration of his 1534 German Bible. Such printed pictures were carefully labeled to control interpretation; not being part of the liturgy, they did not invite devotional adoration, nor were

29. Michalski, *The Reformation and the Visual Arts*, 4, 20; Seasoltz, *A Sense of the Sacred*, 36, 171; McDannell, *Material Christianity*, 9–10. Nominalism also shaped Luther's view on humanity's distance from God, a worldview vastly different from that of Catholicism and Orthodoxy.

30. Michalski, *The Reformation and the Visual Arts*, 7–9; McDannell, *Material Christianity*, 10; Belting, *Likeness and Presence*, 459, 463.

31. Michalski, *The Reformation and the Visual Arts*, 34–35.

32. Ibid., 6–7.

33. Ibid., 23–24; Morgan, *Icons of American Protestantism*, 4; Belting, *Likeness and Presence*, 458, 460, 463.

they dangerously vivid or sensuous.[34]

The Reformed tradition historically tended to be more iconoclastic. Andreas Bodenstein von Karlstadt (1480–1541), Ulrich Zwingli (1484–1531), and John Calvin (1509–1564) each had reasons for banishing images from churches. Karlstadt was involved in various image disputes through the 1520s; concerned first with the faithful being misled by "internal idols," he called for religious images to be removed immediately. Believing that images teach only "fleshly desires,"

*Luther encouraged the use of religious images as illustrations, as seen in woodcuts used in his 1523 translation of the New Testament.*

he admitted having a genuine fear of them.[35] Zwingli, the most political reformer (and intensely iconoclastic), was convinced that "nothing based on corporeal elements can lead to salvation."[36] He denounced the cult of the saints as being idolatrous and emphasized that Jesus Christ was to be the only mediator between humanity and God.[37] He opposed unrestrained iconoclasm but in 1524 decided that

34. Michalski, *The Reformation and the Visual Arts*, 31–33, 119; Freedberg, *The Power of Images*, 399; McDannell, *Material Christianity*, 9; Seasoltz, *A Sense of the Sacred*, 173.

35. Michalski, *The Reformation and the Visual Arts*, 23–25, 43–45.

36. Ibid., 51; McDannell, *Material Christianity*, 13.

37. Michalski, *The Reformation and the Visual Arts*, 52, 55.

all images should be removed in Zurich, leaving the churches, in his words, "beautifully white" (*hübsch wyss*) save stained-glass windows. Aiming to be rid of all concrete manifestations of the church that he deemed irrelevant to the inner life, Zwingli allowed no crucifixes or images of Christ; pure divinity cannot be seen.[38] Yet he did eventually relax his view to allow for images of Christ's humanity in people's homes.[39] Like Luther, he believed money spent on art was better used to serve the poor.[40]

Calvin, the most systematic reformer, abolished religious art in Geneva in 1535. For him, making images was a "misunderstanding of the essence of God," part of the "cult of the external" that he would denounce in favor of "spiritual knowledge."[41] In his *Institutes of the Christian Religion*, he echoed early iconoclasts in his belief that depicting Christ's resurrected body would be an affront to God's majesty.[42] Calvin considered miracles related to images and relics to be products of superstition but allowed some ornamentation in churches if it would help "incline the faithful to practice holy things with humility, devotion, and worship."[43] He was particularly devoted to inscriptions from the Bible, as they made visible the voice of God; yet he considered

38. Ibid., 52–54, 186; Seasoltz, *A Sense of the Sacred*, 164.

39. Michalski, *The Reformation and the Visual Arts*, 56.

40. Ibid., 55.

41. Ibid., 62, 65, 105; Morgan, *Icons of American Protestantism*, 4–5.

42. Michalski, *The Reformation and the Visual Arts*, 62; Morgan, *Icons of American Protestantism*, 5. Calvin's concern with depicting Christ reflected in part his deep belief that after the resurrection, Christ's body was in spiritual unity with God the Father; from Calvin's view, if Jesus was in heaven, he was not also present on earth.

43. Michalski, *The Reformation and the Visual Arts*, 67–68.

images in public places acceptable as long as they were unlikely to evoke a cult response.[44]

In general, attitudes toward images have tended to parallel denominational beliefs about the real presence of Christ in the Eucharist.[45] While Luther gave moderate support to both religious art and a sense of the physical, sacramental presence of Christ, Karlstadt, Zwingli, and Calvin tended to call for the eradication of both images and the idea of Christ physically present in the Eucharist. For most Protestants, a perceived abyss between God and humanity meant that "it was a serious error on the part of humanity to attempt, through monuments, images, or other material things, to try to enter into a direct relationship with God."[46]

Protestant iconoclasm during the Reformation, similarly, ranged from quiet, peaceful reduction of the use of images to violent mockery of the images being destroyed. Some images were given almost ritual burnings; sculptures were decapitated and limbs broken off; some were run through

44. Ibid., 70; Freedberg, *The Power of Images*, 399. Seasoltz, *A Sense of the Sacred*, 175: It is good to remember that well-known artists, such as Rembrandt van Rijn (1606–1669, of Dutch Calvinist or Mennonite background), were painting religious subjects during this time. Some of Rembrandt's religious work is profoundly tender and reflective.

45. Michalski, *The Reformation and the Visual Arts*, 169–79: Since eighth-century iconoclastic arguments, the language of image and reality has been applied to discussions of the sacramental nature of the Eucharist. In Reformation discussion, "idolatry" became a common epithet concerning the cult of the Eucharist. More recently, twentieth-century Benedictine Odo Casel used the language of religious imagery to say that the Eucharist is "an iconic representation" of its prototype.

46. Seasoltz, *A Sense of the Sacred*, 171.

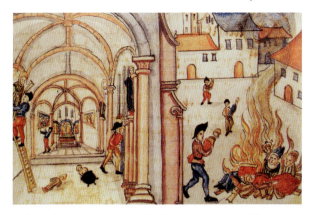

*Reformation-era destruction of religious images ranged from peaceful removal to violent mockery. ("Destruction of Icons in Zurich," 1524.)*

with swords and eyes gouged out.[47] Often, punishing images as effigies took the place of dogmatic controversy; it served as a way to physically attack a representative of Catholicism.[48] Drastic responses to religious images reflected the difficulty of personal and communal redefinition. Iconoclasm was, in some cases, a manner of battling one's

47. On Protestant iconoclasm, see Michalski, *The Reformation and the Visual Arts*, 75–96; Belting, *Likeness and Presence*, 459–65; William R. Jones, "Art and Christian Piety: Iconoclasm in Medieval Europe," 75–95; Carl C. Christensen, "Patterns of Iconoclasm in the Early Reformation: Strasbourg and Basel," 107–48; and William S. Maltby, "Iconoclasm and Politics in the Netherlands, 1566," 149–64; all in *The Image and the Word: Confrontations in Judaism, Christianity and Islam,* ed. Joseph Gutmann (Missoula, MT: Scholars Press, 1977). The second part of Eamon Duffy's masterful *The Stripping of the Altars: Traditional Religion in England 1400–1580* (New Haven, CT: Yale University Press, 1992) deals with Anglican iconoclasm.

48. Michalski, *The Reformation and the Visual Arts*, 90.

own traditional sense of innate presence in images. According-ing to Michalski, it is

> the projection of a certain fear deeply rooted in the people of the time: namely, the quasi-magical fear of figures coming to life, fear of the very principle of showing the sacredness in an image that aspires to be a likeness. . . . Accepting an image as the bearer or means of transmission of the sacred assumed a certain type of symbolic acquiescence or submission to the force of tradition.[49]

Iconoclasm dealt with outward forms in a way that assisted acknowledgment of inward change.

> Almost always, however, iconoclasm meant the crossing of a particular point of no return in relation to the old faith. The fact of the matter is that this point happened to vary in accordance with the course of the Reformation in each town. Sometimes iconoclasm accompanied the taking-over of the first churches; more often it marked the watershed when the Protestants appeared as the stronger confession; sometimes it symbolically demonstrated their final triumph, which usually happened when the town council decided to expel the rest of the Catholic clergy from the town.[50]

Though no major Reformation leader praised the use of violence against images, Thomas Münzer (1489–1525) came close, with his followers destroying a Marian pilgrimage chapel in 1524.[51] Moreover, although Protestants

49. Ibid., 96.
50. Ibid., 79–80.
51. Ibid., 23, 77.

usually looked to define themselves against Catholicism, where the new faith existed alongside Eastern Orthodoxy, the issue of images became central to how the Churches perceived each other for at least three hundred years.[52]

In terms of the English Reformation and the Anglican Church, Eamon Duffy has argued that iconoclasm and reform were imposed from above rather than chosen by the people.[53] Thomas Cranmer (1489–1556) believed images should be removed from churches; at the coronation of King Edward in 1547, he remarked, "Your majesty is God's vice-regent and Christ's vicar within your own dominions, and to see with your predecessor Josiah God truly worshipped, and idolatry destroyed, the tyranny of the bishops of Rome banished from your subjects and images removed."[54] Monetary incentives rather than concern for idolatry drove followers of Thomas Cromwell (1485–1540) to remove religious art.[55] Henry VIII (1491–1547) was somewhat more open to images and tried to soften some iconoclasm; in the so-called King's Book (1543), only images that were idolatrously abused were to be prohibited. Yet under Elizabeth I (1533–1603), the Anglican Church was to pursue

52. Ibid., 101. For more on the relationship between Protestantism and Orthodoxy, see Michalski, *The Reformation and the Visual Arts*, 99–168.

53. Duffy, *The Stripping of the Altars*, xxxii–xxxvii. While a commonly given excuse for image removal was the need to prevent the ignorant from falling into idolatry, Freedberg notes that it was not always clear whether it was the educated or the unlettered who really stood at greater risk of idolatry; both seemed to be influenced by images (Freedberg, *The Power of Images*, 399–400).

54. Christopher Irvine and Anne Dawtry, *Art and Worship* (Collegeville, MN: Liturgical Press, 2002), 8.

55. Ibid.

the *via media* regarding images, evolving into something
midway between Calvinist austerity and baroque Catholi-
cism.[56] Seventeenth-century Anglicans often replaced paint-
ings and sculpture in churches with the Ten Commandments
on an eastern wall, and a triptych with the Lord's Prayer
and Creed visually summarized Christian belief.[57]

Certainly American Christianity has been profoundly
shaped by a Protestant sense of division between the sa-
cred and the profane that tends to eliminate the visual. At
some level, however, Colleen McDannell argues, this bi-
furcation is a myth; Protestants have "never been entirely
free from using religious images and spiritual 'helps' in
their lives."[58] A gradual Protestant movement toward im-
ages is evident. While nineteenth-century Protestants like
Adolf von Harnack (1851–1930) wrote regularly about "the
image problem" as they engaged Russian Orthodoxy, be-
tween 1890 and 1920 the tone of ecumenical Protestant
theology began to shift toward greater appreciation of the
"aesthetic qualities of the icon."[59] Certainly staunch theo-
logians like Karl Barth (1886–1968) continued to hold that
images have no place in Protestant churches.[60] The more
moderate Paul Tillich (1886–1965) rejected the kitsch of

56. Ibid., 8–10; see 24–31 regarding further developments in An-
glicanism.

57. Seasoltz, *A Sense of the Sacred*, 182–83.

58. McDannell, *Material Christianity*, 6, 12.

59. Michalski, *The Reformation and the Visual Arts*, 166. See also K.
M. George, "The Contemporary Search for Spirituality," in *A History
of the Ecumenical Movement, Volume 3: 1968–2000*, ed. John Briggs,
Mercy Amba Oduyoye, and Georges Tsetsis (Geneva, Switzerland:
World Council of Churches, 2004), 222.

60. Irvine and Dawtry, *Art and Worship*, 12.

*Warner Sallman's 1940* Head of Christ *is one of the most well-known Protestant devotional images.*

what he saw as "Sunday School art." Tillich instead wrote of the transcendent presence of God in abstract modern art.[61] Yet even with Protestant churches tending to display fewer religious images in their churches than Catholicism or Orthodoxy, Christian images have pervaded Protestant material culture.[62] Popular use of Warner Sallman's 1940 *Head of Christ* and other devotional images of Jesus "shows that in many instances Protestants have experienced images in ways traditionally associated with Roman Catholicism and Eastern Orthodoxy."[63] Even some

61. Ibid., 12–13; McDannell, *Material Christianity*, 10–11; see also Morgan, *Icons of American Protestantism*, 21; Michalski, *The Reformation and the Visual Arts*, 167; McNamara, "Image as Sacrament," 60–61.

62. McDannell, *Material Christianity*, 8, 189–93. See also Morgan, *Icons of American Protestantism*, and David Morgan, *Protestants and Pictures: Religion, Visual Culture, and the Age of American Mass Production* (New York: Oxford University Press, 1999).

63. Morgan, *Icons of American Protestantism*, 3. For Protestants, Warner Sallman's Christ image often parallels Orthodox icons, making the supernatural present (29). The image has the "capacity to make visual, and therefore, in some sense to embody, the personal savior, who 'saves, comforts, and defends' them" (193). Yet where Orthodox faith is primarily communal, Protestant faith is marked by a personal, "*private* response to God's call" (42–43).

miracles connected with the Sallman image have been documented.[64]

Given these developments, today's Protestant interest in icons is not entirely surprising. Recent guidelines for LCMS Lutheran church design, while noting that in the past Protestants "overlooked the potential power of visual art in the service of faith," now consider the arts important.[65] ELCA guidelines likewise emphasize the value of the visual: "Art and architecture proclaim the gospel, enrich the assembly's participation in the word and sacraments, and reinforce the themes of the occasion and season. Liturgical art animates the life and faith of the community."[66] Moreover, "Icons, paintings, and sculpture have a place in the assembly space when they enhance corporate worship and individual devotion."[67] In Great Britain, behind the altar at the Anglican Winchester Cathedral, icons now fill niches once emptied of sculptures during iconoclasm.[68] In the Reformed tradition, the ecumenical Taizé community founded by Swiss Protestants embraces icons as part of their shared

64. Morgan, *Icons of American Protestantism*, 29, 189. Among the miracles attributed to the Sallman image are its turning away a would-be thief; a wallet-sized picture supposedly bled tears in 1979; a Methodist preacher received his call to ministry when the image turned toward him; in 1993 a copy of the image belonging to a Coptic Christian family in Houston secreted a clear oil; their son was miraculously cured of leukemia at the same time.

65. Lutheran Church Education Fund, *Architectural Handbook* (St. Louis, MO: Lutheran Church Missouri Synod, June 3, 2009), 14.

66. Evangelical Lutheran Church in America (ELCA), *Renewing Worship 2: Principles for Worship* (Minneapolis, MN: Augsburg Fortress, 2002), 72.

67. Ibid., 87.

68. Irvine and Dawtry, *Art and Worship*, 68.

*Though founded by Swiss Protestants, the ecumenical community at Taizé, France, uses icons as part of their prayer.*

meditative prayer that has become beloved around the world. What is it about religious images that is so appealing across denominational lines? K. M. George credits an ecumenical rediscovery of Orthodox spiritual classics and devotional practices such as prayer with icons. In icons, he writes, we are aided in perceiving "the beauty and splendour of the Transcendent in which created reality is invited to participate." Icons are a reminder that the world is not hostile to the spirit but is "its bearer . . . capable of becoming the icon of the glory of God."[69] Lutheran scholar and minister Robert Saler says interaction with material culture gives two blessings to Protestants: first is the reinforcement of the sense of incarnation celebrated by Lutherans, Anglicans, and those of a more sacramental bent; second, it helps Protestants move beyond a common weakness of focusing

69. George, "The Contemporary Search for Spirituality," 222, 227.

exclusively on thought and belief, as if Christianity constituted merely accepting certain propositions of faith.[70] As humans composed of both body and spirit, the material world also participates in the spiritual journey.

### Iconography and Ecumenical Dialogue

If it is true that issues of culture tend to be underweighted in ecumenical dialogue,[71] icons seem poised to play a role as a cultural meeting point for a wide variety of Christians. Coming together with respect and admiration around the icon, different Christian voices can speak to what they hold in common, even as differences and painful memories of history are acknowledged. Though some Protestants may be uncomfortable with the idea of elevating one person over another as a saint, the visual example of holiness provided by icons of saints can be a meaningful statement about the work of God in the soul. Post–Vatican II Catholics can be challenged by canonical icons to strengthen the quality of both their devotional prayer life and liturgical art and to be aware of their connection with other Churches. The Orthodox, likewise, in these ecumenical settings, can be challenged to consider how social issues of poverty and injustice figure into a worldview dominated by theosis.[72] While rooted in "what is distinctive to each," when the Churches come together around the icon, they can seek "convergence in a universality which involves an exchange for the sake of mutual enrichment."[73] Praying together, each

---

70. Personal communication with Robert Saler, October 13, 2012.
71. Davies, "What Divides Orthodox and Catholics?," 16.
72. George, "The Contemporary Search for Spirituality," 222.
73. OL, no. 7.

evangelizing in a secularizing world, the Churches can use the icon to show how, in the words of John Paul II, "The language of beauty placed at the service of faith is capable of reaching people's hearts and making them know from within the One whom we dare to represent in images, Jesus Christ, Son of God made man, 'the same yesterday, today, and forever.'"[74]

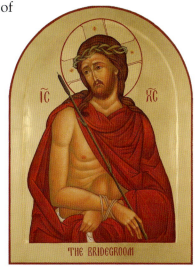

*Created with beauty, the image of Christ has power to draw people together. (Icon of Christ the Bridegroom by the hand of Marek Czarnecki.)*

74. DS, no. 12.

# Conclusion

In Flannery O'Connor's short story "Parker's Back," after covering every other part of his body in tattoos, a man named Obadiah Elihue Parker gets an image of a Byzantine Christ tattooed on his back. His wife Sarah Ruth, described as "plain," and ever concerned to root out any signs of idolatry, initially does not know what to make of it:

> "Another picture," Sarah Ruth growled. "I might have known you was off after putting some more trash on yourself."
>
> Parker's knees went hollow under him. He wheeled around and cried, "Look at it! Don't just say that! *Look* at it!"
>
> "I done looked," she said.
>
> "Don't you know who it is?" he cried in anguish.
>
> "No, who is it?" Sarah Ruth said. "It ain't anybody I know."
>
> "It's him," Parker said.
>
> "Him who?"
>
> "God!" Parker cried.
>
> "God? God don't look like that!"
>
> "What do you know how he looks?" Parker moaned. "You ain't seen him."

"He don't *look*," Sarah Ruth said. "He's a spirit. No man shall see his face."[1]

The daughter of a Straight Gospel preacher, Sarah Ruth is a woman who will have nothing to do with sin; she marries Parker in the county ordinary's office because she believes even churches to be idolatrous. Yet beneath Sarah Ruth's extreme, odd version of religiosity is a tragic blindness to the spiritual truth embodied right before her. She cannot recognize the face of Christ in the material world.

Throughout the history of Christianity, believers and nonbelievers alike have shared Sarah Ruth's battle. Well versed in the Ten Commandments, we fear idolatry, and we perennially struggle to embrace a God who becomes flesh, a God who loves the material world so much that he became a part of it as a human being. Gnosticism early was decided to be heresy because almost immediately it was deemed essential to Christianity that the stuff of us—the matter that is the human body connected with the soul—be sacred. The resurrection of Christ's body and his various appearances afterward to his disciples proving his actual physical reality speak to the importance of the material. The physical and the spiritual go together in Christianity. We are made in the image of God; to say that the physical does not matter is to say that the image of God does not matter. Images *do* matter. As John of Damascus argued, images are a constitutive part of reality.[2]

---

1. Flannery O'Connor, "Parker's Back," in *The Oxford Book of Short Stories*, ed. V. S. Pritchett (New York: Oxford University Press, 1981), 519.

2. Andrew Louth, " 'Beauty Will Save the World': The Formation of Byzantine Spirituality," *Theology Today* 61 (2004): 73–74.

If the simplification of many worship spaces after Vatican II created a vacuum, with too much "simplicity" and not enough "nobility," we should not be surprised at recent Catholic interest in icons. Christians need images to be able to imagine the spiritual world we cannot see, both in communal liturgy and in private devotional prayer. We need images to teach us, to help us understand. Even Protestants rooted in more aniconic traditions have a material, embodied dimension to their Christianity. We need to be able to envision holiness, to imagine what it looks like for those who have gone before us, and to imagine it for our own spiritual lives. While the apophatic way of mysticism ultimately leads into the enveloping mystery of a God transcending all images and words, the apophatic has historically been counterbalanced with the kataphatic way, the way of description and images. No single image is sufficient, of course. As Christ became human so as to bring all humanity into his own life, so the life and love of God are embodied in millions of different faces. In a redeemed world, we have to learn to see, to recognize Christ's face in the other.

The question of recognizability in icons bears further study and discussion. Theologically, we can say that the Church is catholic, universal. Christ is present in his Body—not only in those Jews who became his immediate followers but also in the Gentiles: the Greeks, the Italians, the South Africans, the Chinese, the Indians, the Peruvians, the Americans. Christianity must become inculturated wherever it takes root, and we must learn to recognize the face of Christ in the unfamiliar. We must be able to see ourselves, whoever we are, in the image of Christ. Yet in the world of the icon, we have canonical norms for depicting

Christ in certain ways. Jesus is recognizable when iconographers follow prototypes based on a common understanding of how to image him. The work of Catholic iconographers like Robert Lentz and William Hart McNichols, while occasionally disturbing in terms of its relation to the canons of iconography, raises precisely this issue of what it means for Christ to be recognizable. Can Christ be recognized by *everyone* who views the image? When we choose to depict Christ in our own image, we are thrown into the natural tension between the Church local and the Church universal. Yes, God became human in Jesus, in a very particular way, at a particular time, in a particular place. But God now also becomes flesh in a universal way: every day, at every Eucharist, in every baptized Christian, and thus again in very particular ways. In our own image making, how do we recognize the dignity and sacrality of Christ present today, embodied in the poor and the oppressed, in the disenfranchised and the lonely, in every human person created in God's image?

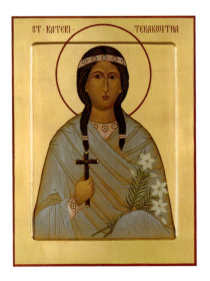

Especially as migration patterns contribute to ever more diverse faith communities, it is important that Churches work to include religious art that helps

*As the church becomes inculturated in different parts of the world, it is important that icons reflect the face of Christ in newer saints. (Icon of St. Kateri Tekakwitha, by the hand of Marek Czarnecki.)*

every person to feel welcome at the table. Our sacred images should help us to see ourselves in the Body of Christ.[3] The icon, while rooted in a tradition perhaps best known in its Greek and Russian forms, also springs from Egypt, from Ethiopia, from Armenia, Georgia, and Italy. In its stylization, the icon is both particular and universal as it depicts deified reality, a glimpse of the world of heaven. Thus as communities discern how to integrate art into their liturgical, devotional, and educational spaces, the icon can make present a universal reality that transcends the diversity of the local community.

If current Catholic interest in icons continues to grow, it seems important that the Church eventually articulate some position regarding acceptable standards for iconography and iconographers. The visual content and the level of quality required of icons to adorn churches or other public places matter. This is not to say all "Catholic icons" must mimic "Orthodox icons." Certainly "Catholic icons" will depict Catholic teachings that may not be presented in the same way as in Orthodoxy. A depiction of Mary's assumption necessarily will visually differ from an icon of the dormition, even though the underlying substance of the belief depicted may be fundamentally the same: Mary was pure in body and soul, and she went to heaven. Orthodoxy does not have devotion to the Sacred Heart of Jesus or the Immaculate Heart of Mary, yet these would be fitting images for Catholic iconography. More broadly speaking, where

---

3. See Mark R. Francis, *Liturgy in a Multicultural Community* (Collegeville, MN: Liturgical Press, 1991), 52, 62–63; Richard S. Vosko, *God's House Is Our House: Re-imagining the Environment for Worship* (Collegeville, MN: Liturgical Press, 2006), 189–93.

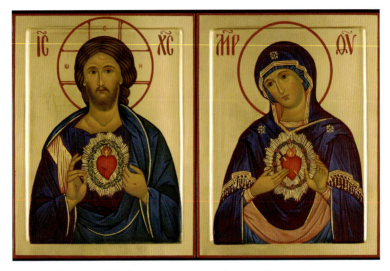

*Quality "Catholic icons" may depict devotional images foreign
to Orthodox tradition, even as they are created following
Eastern principles. (Sacred Heart of Jesus and Immaculate
Heart of Mary. Icons by the hand of Marek Czarnecki.)*

the articulation of the faith is similar in both Catholicism
and Orthodoxy, it would seem fitting that the Roman
Church support traditional Orthodox canons for how to
depict subjects. Iconographers ought to be held up to
similar standards of technical work. Eventually, the Catholic
Church may also come to require, or at least recommend,
standards of spiritual and moral behavior for iconogra-
phers. Asceticism at the service of sacramental life is al-
ready something of a theme in the Catholic priesthood; in
time, perhaps iconographers could come to be viewed with
similar concern. Addressing some of these issues of culture
at the episcopal level could enhance understanding be-
tween the Churches.

Icons are not simply art like other religious art. It will
take ongoing catechesis for the majority of Catholics to

gain an understanding of what icons actually are and an appreciation of their sacramental nature. In the face of an age of mass-produced prints, increasing general access to high-quality original icons will help convey the power of these images. Those responsible for arranging worship spaces likewise can help increase comfort with icons by designing spatial contexts that will suggest how best to interact with them. Although icons properly require a particular kind of reverence, and sensitive use is warranted, they can find a place in Catholic churches among a diversity of other sacred art. Whether used for liturgical, devotional, or historical purposes, icons have a role to play in making the spiritual world visible.

Ultimately, it is the transcendence of the icon that enables it to be "intuitively ecumenical," as Mahmoud Zibawi puts it.[4] Around the icon, Orthodox, Catholics, and Protestants can have conversation that engages differences while also inviting the "other" to become "neighbor." When together we can recognize the holiness of the ones depicted, we are sharing in a common vision. When together we can speak about what we literally see, we begin to be able to speak of what we see figuratively. While only the Holy Spirit can rebuild the unity of the fractured Body of Christ, as Christians we are called to be willing participants in the process of salvation. In the icon is a meeting point to start such healing.

Finally, to our wider world the icon offers a vision of coherence and wholeness that goes beyond pat answers and one-dimensional thinking. To our media-saturated generation, the icon offers an invitation to see with new

---

4. Mahmoud Zibawi, *The Icon: Its Meaning and History* (Collegeville, MN: Liturgical Press, 1993), 150.

eyes of reverence and respect. To a world of war and sense-less violence and noise, the icon offers space for healing, for silence, for holiness, and for peace. The icon invites us to see meaning, to see depth within our own space, to see beyond simple appearances to the exquisite nature of a reality far more mysterious than we can fathom. Whether we choose to recognize it or not, life is sacramental, and grace is breaking in on our world. It is my hope that in exploring the world of icons, Catholics and Protestants alike can be brought to a place of greater appreciation for this deifying light.

# Bibliography

Aghiorgoussis, Maximos. *In the Image of God*. Brookline, MA: Holy Cross Orthodox Press, 1999.

Andaloro, Maria. "Polarità bizantine, polarità romane nelle pitture di Grottaferrata." In *Italian Church Decoration of the Middle Ages and Early Renaissance*, edited by William Tronzo, 13–26. Bologna: Nuova Alfa Editoriale, 1989.

Anderson, Jeffrey C. "The Byzantine Panel Portrait before and after Iconoclasm." In *The Sacred Image East and West*, edited by Leslie Brubaker and Robert Ousterhout, 25–44. Urbana, IL: University of Illinois Press, 1995.

Andreaopolos, Andreas. *Art as Theology: From the Postmodern to the Medieval*. Oakville, CT: Equinox, 2006.

Anthimos VII. *Orthodox and Catholic Union: The Reply of the Holy Orthodox Church to Roman Catholic Overtures on Reunion and Ecumenism*. Seattle, WA: St. Nectarios Press, 1985.

Ashley, Kathleen. "Hugging the Saint: Improvising Ritual on the Pilgrimage to Santiago de Compostela." In *Push Me, Pull You: Imaginative and Emotional Interaction in Late Medieval and Renaissance Art*, Vol. 2, edited by Sarah Blick and Laura D. Gelfand, 3–20. Boston: Brill, 2011.

Barasch, Moshe. *Icon: Studies in the History of an Idea*. New York: New York University Press, 1992.

Basil the Great. *On the Holy Spirit*. Translated by David Anderson. Crestwood, NY: St. Vladimir's Seminary Press, 1980.

Belting, Hans. "The Invisible Icon and the Icon of the Invisible: Antonello and New Paradigms in Renaissance Painting." In *Watching Art: Writings in Honor of James Beck*, edited by Lynn Catterson and Mark Zucker, 73–83. Todi, Peruggia: Ediart, 2006.

———. *Likeness and Presence*. Translated by Edmund Jephcott. Chicago: University of Chicago Press, 1994.

Bergmann, Sigurd. *In the Beginning Is the Icon: A Liberative Theology of Images, Visual Arts and Culture*. Translated by Anja K. Angelsen. Oakville, CT: Equinox, 2009.

"Biography." Franciscan Icons by Robert Lentz. June 19, 2012. http://robertlentzartwork.wordpress.com/.

Blick, Sarah. "Images, Interaction and Pilgrimage to the Tomb and Shrine of St. Thomas Becket, Canterbury Cathedral." In *Push Me, Pull You: Imaginative and Emotional Interaction in Late Medieval and Renaissance Art*, Vol. 2, edited by Sarah Blick and Laura D. Gelfand, 21–58. Boston: Brill, 2011.

Bloemsma, Hans. "Venetian Crossroads: East and West and the Origins of Modernity in Twelfth-Century Mosaics in San Marco." *Journal of Intercultural Studies* 31, no. 3 (2010): 299–312.

Boston, Karen. "The Power of Inscriptions and the Trouble with Texts." In *Icon and Word: The Power of Images in Byzantium*, edited by Antony Eastmond and Liz James, 35–57. Burlington, VT: Ashgate Publishing, 2003.

Boyle, Marjorie O'Rourke. "Christ the Eikon in the Apologies for Holy Images of John of Damascus." *Greek Orthodox Theological Review* 15 (1970): 175–86.

Brock, Sebastian. "Iconoclasm and the Monophysites." In *Iconoclasm*, edited by Anthony Bryar and Judith Herrin, 53–57. Birmingham, UK: Center for Byzantine Studies, University of Birmingham, 1977.

Brubaker, Leslie. "The Sacred Image." In *The Sacred Image East and West*, edited by Leslie Brubaker and Robert Ousterhout, 1–24. Urbana, IL: University of Illinois Press, 1995.

Buckley, Theodore Alois. *The Canons and Decrees of the Council of Trent*. London: Routledge, 1851.

Busi, Gianluca. *Il Segno di Giona*. Bologna: Dehoniana Libri, 2011.

Bynum, Caroline. *Wonderful Blood: Theology and Practice in Late Medieval Northern Germany and Beyond*. Philadelphia, PA: University of Pennsylvania Press, 2007.

Cameron, Averil. "Elites and Icons in Late Sixth-Century Byzantium." *Past and Present* 84, no. 1 (August 1979): 3–35.

———. "The Language of Images: The Rise of Icons and Christian Representation." In *The Church and the Arts*, edited by Diana Wood, 1–42. Cambridge, MA: Blackwell Publishers, 1992.

Canon Law Society of America. *Code of Canon Law: Latin-English Edition*. Washington, DC: Canon Law Society of America, 1989.

Cavarnos, Constantine. *Ecumenism Examined*. Belmont, MA: Institute for Byzantine and Modern Greek Studies, 1996.

Chambers, Claire Maria. "The Common and the Holy: What Icons Teach Us about Performance." *Liturgy* 28, no. 1 (January 2013): 18–30.

Christensen, Carl C. "Patterns of Iconoclasm in the Early Reformation: Strasbourg and Basel." In *The Image and the Word: Confrontations in Judaism, Christianity and Islam*, edited by Joseph Gutmann, 107–48. Missoula, MT: Scholars Press, 1977.

Congregation for Divine Worship and the Discipline of the Sacraments. *Directory on Popular Piety and the Liturgy: Principles and Guidelines*. Vatican City, December, 2001.

Congregation on the Clergy. "*Opera Artis*: Circular Letter on the Care of the Church's Historical and Artistic Heritage." April 11, 1971. In *Documents on the Liturgy 1963–1979: Conciliar, Papal, and Curial Texts*, edited by International Commission on English in the Liturgy, 1358–1360. Collegeville, MN: Liturgical Press, 1982.

Cormack, Robin. *Painting the Soul: Icons, Death Masks, and Shrouds*. London: Reaktion Books, 1997.

Czarnecki, Marek. *The Technique of Iconography: Method and Teachings of Xenia Pokrovskaya and the Izograph School of Iconography*. Sharon, MA: Izograph Studio, 2003.

D'Antiga, Renato. *Guida alla Venezia Bizantina*. Padova: Casadei Libri, 2005.

Dale, Thomas E. A. *Relics, Prayer, and Politics in Medieval Venetia: Romanesque Painting in the Crypt of Aquileia Cathedral*. Princeton, NJ: Princeton University Press, 1997.

Davies, Maximos. "What Divides Orthodox and Catholics?" *America* 197, no. 18 (December 3, 2007): 15–17.

DeSanctis, Michael E. *Building from Belief: Advance, Retreat, and Compromise in the Remaking of Catholic Church Architecture*. Collegeville, MN: Liturgical Press, 2002.

Dionysius of Fourna. *The "Painter's Manual" of Dionysius of Fourna*. Translated by Paul Hetherington. London: Sagittarius Press, 1974.

Dragas, George D. *Ecclesiasticus II: Orthodox Icons, Saints, Feasts and Prayer*. Rollinsford, NH: Orthodox Research Institute, 2005.

Duffy, Eamon. *The Stripping of the Altars: Traditional Religion in England 1400–1580*. New Haven, CT: Yale University Press, 1992.

Dukes, Mark. "St. John Coltrane Enthroned." Fine Art America. www.fineartamerica.com/featured/saint-john-cotrane -enthroned-mark-dukes.html.

Eastmond, Antony. "Between Icon and Idol: The Uncertainty of Imperial Images." In *Icon and Word: The Power of Images in Byzantium*, edited by Antony Eastmond and Liz James, 73–85. Aldershot, Hampshire, England: Ashgate Publishing, 2003.

Egenter, Richard. *The Desecration of Christ*. Edited by Nicolette Gray. Translated by Edward Quinn. Chicago, IL: Franciscan Herald Press, 1967.

Elkins, J., and R. Williams. *Renaissance Theory*. New York: Routledge, 2008.

Evangelical Lutheran Church in America. *Renewing Worship 2: Principles for Worship*. Minneapolis, MN: Augsburg Fortress, 2002.

Falla Castelfranchi, Marina. "Disiecta membra. La pittura bizantina in Calabria (secoli IX–XII)." In *Italian Church Decoration of the Middle Ages and Early Renaissance*, edited by William Tronzo, 81–100. Bologna: Nuova Alfa Editoriale, 1989.

Ferrone, Rita. "Reception in Context: Historical, Theological, and Pastoral Reflections." In *One at the Table: The Reception of Baptized Christians*, edited by Ronald A. Oakham, 21–41. Chicago: Liturgical Training Publications, 1995.

Fingesten, Peter. "Toward a New Definition of Religious Art." *Art Journal* 10, no. 2 (1951): 131–46.

Folda, Jaroslav. "Crusader Art." In *Glory of Byzantium: Art and Culture of the Middle Byzantine Era A.D. 843–1261*, edited by Helen C. Evans and William D. Wixom, 388–401. New York: Harry N. Abrams, 1997.

Francis, Mark R. *Liturgy in a Multicultural Community*. Collegeville, MN: Liturgical Press, 1991.

Freedberg, David. *The Power of Images: Studies in the History and Theory of Response*. Chicago: University of Chicago Press, 1989.

Garcia, Juan Luis Gonzalez. "Empathetic Images and Painted Dialogues: The Visual and Verbal Rhetoric of Royal Private Piety in Renaissance Spain." In *Push Me, Pull You: Imaginative and Emotional Interaction in Late Medieval and Renaissance Art*, Vol. 1, edited by Sarah Blick and Laura D. Gelfand, 487–523. Boston: Brill, 2011.

Gelfand, Laura D., and Sarah Blick. Introduction to *Push Me, Pull You: Imaginative and Emotional Interaction in Late Medieval and Renaissance Art*, Vol. 1, edited by Sarah Blick and Laura D. Gelfand, xxxii–lii. Boston: Brill, 2011.

———, eds. *Push Me, Pull You: Imaginative and Emotional Interaction in Late Medieval and Renaissance Art*. 2 Vols. Boston: Brill, 2011.

George, K. M. "The Contemporary Search for Spirituality." In *A History of the Ecumenical Movement, Volume 3: 1968–2000*, edited by Mercy Amba Oduyoye, Georges Tsetsis, and John Briggs, 217–41. Geneva, Switzerland: World Council of Churches, 2004.

Georgopoulou, Maria. "Late Medieval Crete and Venice: An Appropriation of Byzantine Heritage." *The Art Bulletin* 77, no. 3 (September 1997): 479–96.

Gibson, Walter. "Prayers and Promises: The Interactive Indulgence Print." In *Push Me, Pull You: Imaginative and Emotional Interaction in Late Medieval and Renaissance Art*, Vol. 1, edited by Sarah Blick and Laura D. Gelfand, 277–24. Boston: Brill, 2011.

Gómez, Raúl R. "Veneration of the Saints and *Beati*." In *Directory on Popular Piety and the Liturgy: Principles and Guidelines: A Commentary*, edited by Peter C. Phan, 113–33. Collegeville, MN: Liturgical Press, 2005.

Guida, Maria Pia de Dario. *Icone di Calabria e Altre Icone Meridonali*. Messina: Rubbettino, 1992.

Hambye, E. R. "Problems and Prospects of Ecumenism in the Eastern Catholic Churches." In *Oriental Churches: Theological Dimensions*, edited by Xavier Koodapuzna, 242–49. Kerala, India: Oriental Institute of Religious Studies Publications, 1988.

Hart, Aiden. *Techniques of Icon and Wall Painting*. Leominster, Herefordshire, Australia: Gracewing, 2011.

Huels, John M. *New Commentary on the Code of Canon Law*, edited by John P. Beal, James A. Coriden, and Thomas A. Green. New York: Paulist Press, 2000.

Iakovos, Archbishop of the Greek Orthodox Diocese of North and South America. *That They May Be One: Position Papers, Essays, Homilies, and Prayers on Christian Unity*, edited by Demetrios J. Constantelos. Brookline, MA: Holy Cross Orthodox Press, 2007.

International Commission on English in the Liturgy. *A Book of Blessings*. Collegeville, MN: Liturgical Press, 1989.

———. *Documents on the Liturgy 1963–1979: Conciliar, Papal, and Curial Texts*. Collegeville, MN: Liturgical Press, 1982.

Irvine, Christopher, and Anne Dawtry. *Art and Worship*. Collegeville, MN: Liturgical Press, 2002.

Jacobs, Fredrika H. "Images, Efficacy and Ritual in the Renaissance: Burning the Devil and Dusting the Madonna." In *Push Me, Pull You: Imaginative and Emotional Interaction in Late Medieval and Renaissance Art*, Vol. 2, edited by Sarah Blick and Laura D. Gelfand, 147–75. Boston: Brill, 2011.

———. "Rethinking the Divide: Cult Images and the Cult of Images." In *Renaissance Theory: The Art Seminar*, edited by James Elkins and Robert Williams, 95–114. New York: Routledge, 2008.

Jillions, John A. "Three Orthodox Models of Christian Unity: Traditionalist, Mainstream, Prophetic." *International Journal for the Study of the Christian Church* 9, no. 4 (2009): 295–311.

John XXIII. "Sacred Art." October 28, 1961. In *The New Liturgy: A Documentation 1903–1965*, edited by R. Kevin Seasoltz, 175–77. New York: Herder and Herder, 1966.

John of Damascus. *Three Treatises on the Divine Images*. Translated by Andrew Louth. Crestwood, NY: St. Vladimir's Seminary Press, 2003.

John Paul II. *Duodecimum Saeculum*. December 4, 1987. http:// www.vatican.va/holy_father/john_paul_ii/apost_letters /documents/hf_jp-ii_apl_19871204_duodecim-saeculum _en.html.

———. *Ecclesia de Eucharistia*. April 17, 2003. http://www.vatican .va/holy_father/special_features/encyclicals/documents/ hf_jp-ii_enc_20030417_ecclesia_eucharistia_en.html.

———. *Letter to Artists*. Chicago: Liturgy Training Publications, 1999.

———. *Orientale Lumen: Apostolic Letter on the Eastern Churches*. May 2, 1995. http://www.vatican.va/holy_father/john _paul_ii/apost_letters/documents/hf_jp-ii_apl_02051995 _orientale-lumen_en.html.

Johnson, Maxwell. *Rites of Christian Initiation: Their Evolution and Interpretation*. Collegeville, MN: Liturgical Press, 2007.

Jones, William R. "Art and Christian Piety: Iconoclasm in Medieval Europe." In *The Image and the Word: Confrontations in*

*Judaism, Christianity and Islam*, edited by Joseph Gutmann, 75–95. Missoula, MT: Scholars Press, 1977.

Kazanaki-Lappa, Maria. *Arte Bizantina e Postbizantina a Venezia*. Translated from Greek to Italian by Angeliki Tzavara. Villorba: Eurocrom, 2009.

Kieckhefer, Richard. "Holiness and the Culture of Devotion: Remarks on Some Late Medieval Male Saints." In *Images of Sainthood in Medieval Europe*, edited by Renate Blumenfeld-Kosinski and Timea Szell, 288–305. Ithaca, NY: Cornell University Press, 1991.

Kitzinger, Ernst. "Mosaic Decoration in Sicily under Roger II and the Classical Byzantine System of Church Decoration." In *Italian Church Decoration of the Middle Ages and Early Renaissance*, edited by William Tronzo, 147–65. Bologna: Nuova Alfa Editoriale, 1989.

———. "The Cult of Images in the Age before Iconoclasm." Edited by W. Eugene Klembauer. *Dumbarton Oaks Papers* 8 (1954): 83–150. Reprinted in *The Art of Byzantium and the Medieval West: Selected Studies*, edited by W. Eugene Kleinbauer, 90–156. Bloomington, IN: Indiana University Press, 1976.

Klein, Holger E. "Eastern Objects and Western Desires: Relics and Reliquaries between Byzantium and the West." *Dumbarton Oaks Papers* 58 (2004): 283–314.

Leeming, Bernard. "Orthodox-Catholic Relations." In *Re-discovering Eastern Christendom*, edited by A. H. Armstrong and E. J. B. Fry, 15–50. London: Darton, Longman & Todd, 1963.

Lentz, Robert. "Celtic Trinity." Trinity Stores. https://www.trinitystores.com/store/art-image/celtic-trinity.

———. "Christ of Maryknoll." Trinity Stores. https://www.trinitystores.com/store/art-image/christ-maryknoll.

———. "Sts. Brigid and Darlughdach of Kildare." Trinity Stores. https://www.trinitystores.com/store/art-image/sts-brigid-and-darlughdach-kildare.

————. "Trinity Religious Artwork and Icons." Trinity Stores. https://www.trinitystores.com/store/artist/Robert-Lentz.

Lewis, Flora. "Rewarding Devotion: Indulgences and the Promotion of Images." In *The Church and the Arts*, edited by Diana Wood, 179–94. Cambridge, MA: Blackwell Publishing, 1992.

LeZotte, Annette. "Cradling Power: Female Devotions and Early Netherlandish Jesueaux." In *Push Me, Pull You: Imaginative and Emotional Interaction in Late Medieval and Renaissance Art*, Vol. 2, edited by Sarah Blick and Laura D. Gelfand, 59–84. Boston: Brill, 2011.

Liebacher Ward, Susan. "Who Sees Christ? An Alabaster Panel of the Mass of St. Gregory." In *Push Me, Pull You: Imaginative and Emotional Interaction in Late Medieval and Renaissance Art*, Vol. 1, edited by Sarah Blick and Laura D. Gelfand, 347–81. Boston: Brill, 2011.

Lossky, Vladimir, and Leonid Ouspensky. *The Meaning of Icons*. Translated by G. E. H. Palmer and E. Kadloubovsky. Crestwood, NY: St. Vladimir's Seminary Press, 1982.

Louth, Andrew. " 'Beauty Will Save the World': The Formation of Byzantine Spirituality." *Theology Today* 61 (2004): 67–77.

————. *St. John Damascene: Tradition and Originality in Byzantine Theology*. New York: Oxford University Press, 2002.

Lutheran Church Education Fund. *Architectural Handbook*. St. Louis, MO: Lutheran Church Missouri Synod, June 3, 2009.

Madey, John. *Ecumenism, Ecumenical Movement and Eastern Churches*. Kerala, India: Oriental Institute of Religious Studies Publications, 1987.

Maffeis, Angelo. *Ecumenical Dialogue*. Translated by Lorelei F. Fuchs. Collegeville, MN: Liturgical Press, 2005.

Maltby, William S. "Iconoclasm and Politics in the Netherlands, 1566." In *The Image and the Word: Confrontations in Judaism, Christianity and Islam*, edited by Joseph Gutmann, 149–64. Missoula, MT: Scholars Press, 1977.

Manoussacas, M., and Ath. Paliouras. *Guide to the Museum of Icons and the Church of Saint George*. Venice: Aspioti-Elka, 1976.

Marino, Antonino. *Storia della Legislazione sul Culto delle Immagini dall'inizio fino al trionfo dell'Ortodossia*. Rome: Pontificium Institutum Orientale, 1991.

Maritain, Jacques. *Art and Scholasticism*. New York: Charles Scribner's Sons, 1930.

Mathews, Thomas F. *Byzantium: From Antiquity to the Renaissance*. New York: Harry N. Abrams, 1998.

———. "Psychological Dimensions in the Art of Eastern Christendom." In *Art and Religion: Faith, Form, and Reform*, edited by Osmond Overby, 1–21. Columbia, MO: University of Missouri, 1986.

McDannell, Colleen. *Material Christianity*. New Haven, CT: Yale University Press, 1995.

McGuckin, John A. "The Theology of Images and the Legitimization of Power in Eighth Century Byzantium." *St. Vladimir's Theological Quarterly* 37, no. 1 (1993): 39–58.

McNamara, Denis R. *Catholic Church Architecture and the Spirit of the Liturgy*. Chicago: Liturgy Training Publications, 2009.

———. "Image as Sacrament: Rediscovering Liturgical Art." In *Sacrosanctum Concilium and the Reform of the Liturgy*, edited by Kenneth D. Whitehead, 57–71. Chicago: University of Scranton Press, 2009.

McNichols, William Hart. "Princess Diana: Friend of the Sick, the Outcast and Victims of Violence." St. Andrei Rublev Icons. 2008. http://www.fatherbill.org/gallery.php?action=viewPicture.

———. "The Triumph of the Immaculate Heart." St. Andrei Rublev Icons. January 2, 2013. http://www.fatherbill.org/gallery.php?action=viewPicture.

Michalski, Sergiusz. *The Reformation and the Visual Arts*. New York: Routledge, 1993.

Morgan, David. *Icons of American Protestantism*. New Haven, CT: Yale University Press, 1996.

———. *Protestants and Pictures: Religion, Visual Culture, and the Age of American Mass Production*. New York: Oxford University Press, 1999.

Morris, Amy M. "Art and Advertising: Late Medieval Altarpieces in Germany." In *Push Me, Pull You: Imaginative and Emotional Interaction in Late Medieval and Renaissance Art*, Vol. 1, edited by Sarah Blick and Laura D. Gelfand, 325–45. Boston: Brill, 2011.

Musser, Benjamin. "Letter to the Editor." *Liturgical Arts* 1, no. 2 (Winter 1932): 78.

National Conference of Catholic Bishops. *Built of Living Stones: Art, Architecture, and Worship*. Washington, DC: United States Catholic Conference, 2000.

———. *Environment and Art*. Washington, DC: United States Catholic Conference, 1978.

Neff, Amy. "Byzantium Westernized, Byzantium Marginalized: Two Icons in the *Supplicationes Varie*." *Gesta* 38, no. 1 (1999): 81–102.

Nelson, Robert. "A Byzantine Painter in Trecento Genoa: The Last Judgment at San Lorenzo." *The Art Bulletin* 67, no. 4 (December 1985): 548–66.

Nelson, Robert S., and Kristen M. Collins. *Holy Image, Hallowed Ground: Icons from Sinai*. Los Angeles: J. Paul Getty Museum, 2006.

Noble, Thomas F. X. *Images, Iconoclasm, and the Carolingians*. Philadelphia, PA: University of Pennsylvania Press, 2009.

O'Connor, Flannery. "Parker's Back." In *The Oxford Book of Short Stories*, edited by V. S. Pritchett, 501–19. New York: Oxford University Press, 1981.

Onasch, Konrad, and Annemarie Schieper. *Icons: The Fascination and the Reality*. Translated by David G. Conklin. New York: Riverside Book Company, 1997.

Os, Henk van. *The Art of Devotion*. Princeton, NJ: Princeton University Press, 1994.

Ouspensky, Leonid. *Theology of the Icon*. Crestwood, NY: St. Vladimir's Seminary Press, 1978.

Paleotti, Gabriele. *Discourse on Sacred and Profane Images*. Translated by William McCuaig. Los Angeles: Getty Research Institute, 2012.

Parravicini, Giovanna. *Icone Russe della Collezione Orler nel Monastero Greco di Grottaferrata*. Vicenza: Terra Ferma, 2004.

Parry, Kenneth. *Depicting the Word: Byzantine Iconophile Thought of the Eighth and Ninth Centuries*. New York: E. J. Brill, 1996.

Paul VI. "Le nobili espressioni." May 7, 1964. In *The New Liturgy: A Documentation 1903–1965*, edited by R. Kevin Seasoltz, 510–15. New York: Herder and Herder, 1966.

Pecklers, Keith F. *The Unread Vision: The Liturgical Movement in the United States of America 1926–1955*. Collegeville, MN: Liturgical Press, 1998.

Pelikan, Jaroslav. *Imago Dei: The Byzantine Apologia for Icons*. Princeton, NJ: Princeton University Press, 1990.

Peters, Edward N. *Pio-Benedictine Code of Canon Law: In English Translation, with Extensive Scholarly Apparatus, 1917*. San Francisco: Ignatius Press, 2001.

Phan, Peter C., ed. *Director on Popular Piety and the Liturgy: Principles and Guidelines: A Commentary*. Collegeville, MN: Liturgical Press, 2005.

Pius XII. "Instruction of the Holy Office: *De arte sacra*." In *The New Liturgy: A Documentation 1903 to 1965*, 174–78. New York: Herder and Herder, 1966.

———. *Mediator Dei et Hominum*. November 20, 1947. http://www .vatican.va/holy_father/pius_xii/encyclicals/documents /hf_p-xii_enc_20111947_mediator-dei_en.html.

Promey, Sally M. "Interchangeable Art: Warner Sallman and the Critics of Mass Culture." In *Icons of American Protestantism: The Art of Warner Sallman*, edited by David Morgan, 148–80. New Haven, CT: Yale University Press, 1996.

Quenot, Michel. *The Icon: Window on the Kingdom*. Crestwood, NY: St. Vladimir's Seminary Press, 1996.

————. *The Resurrection and the Icon.* Translated by Michael Breck. Crestwood, NY: St. Vladimir's Seminary Press, 1997.

Ringbom, Sixten. *Icon to Narrative: The Rise of the Dramatic Close-up in Fifteenth-Century Devotional Painting.* Doornspijk, Netherlands: Davaco, 1983.

Roman Catholic Church. *Catechism of the Catholic Church.* Vatican City: Libreria Editrice Vaticana, and Chicago: Loyola University Press, 1994.

————. *The Roman Missal: English Translation According to the Third Typical Edition.* Chicago: Liturgy Training Publications, 2011.

Ross Taylor, Lily. "The 'Proskynesis' and the Hellenistic Ruler Cult." *Journal of Hellenistic Studies*, no. 47, Part 1 (1927): 53–62.

Rouet, Albert. *Liturgy and the Arts.* Translated by Paul Philibert. Collegeville, MN: Liturgical Press, 1997.

Sahas, Daniel. *Icon and Logos: Sources in Eighth-Century Iconoclasm.* Toronto: University of Toronto Press, 1985.

Saward, John. *Art, Sanctity and the Truth of Catholicism.* San Francisco: Ignatius Press, 1997.

Schmidt, Suzanne Karr. "Memento Mori: The Deadly Art of Interaction." In *Push Me, Pull You: Imaginative and Emotional Interaction in Late Medieval and Renaissance Art*, Vol. 2, edited by Sarah Blick and Laura D. Gelfand, 261–94. Boston: Brill, 2011.

Seasoltz, R. Kevin. *A Sense of the Sacred: Theological Foundations of Christian Architecture and Art.* New York: Continuum, 2005.

————. *The New Liturgy: A Documentation 1903–1965.* New York: Herder and Herder, 1966.

Second Council of Nicaea. *The Seventh General Council and the Doctrine of Icons, Etc. ("The Definition of the Holy and Great Œcumenical Council, the Second Assembled at Nicæa." The Doctrine of the Seventh General Council of 787 on the Sacred Images Stated in Simple Language, Intelligible to English Minds, at the Conference in the Jerusalem Chamber, Westminster, December 2, 1918).* London: SPCK: 1919.

Sendler, Egon. *The Icon: Image of the Invisible*. Translated by Steven Bigham. Torrance, CA: Oakwood Publications, 1999.

Ševčenko, Nancy Patterson. "Icons in the Liturgy." *Dumbarton Oaks Papers* 45 (1991): 45–57.

———. "The 'Vita' Icon and the Painter as Hagiographer." *Dumbarton Oaks Papers* 53 (1999): 149–65.

Stransky, Thomas F., and John B. Sheerin. *Doing the Truth in Charity: Statements of Pope Paul VI, Popes John Paul I, John Paul II, and the Secretariat for Promoting Christian Unity 1964–1980*. New York: Paulist Press, 1982.

Stubblebine, James. "Byzantine Influence on Thirteenth-Century Italian Panel Painting." *Dumbarton Oaks Papers* 20 (1966): 85–101.

Talbot, Alice-Mary. *Byzantine Defenders of Images*. Washington, DC: Dumbarton Oaks, 1998.

Trowbridge, Mark. "Sin and Redemption in Late Medieval Art and Theater: The Magdalen as Role Model in Hugo Van der Goes's Vienna Diptych." In *Push Me, Pull You: Imaginative and Emotional Interaction in Late Medieval and Renaissance Art*, Vol. 1, edited by Sarah Blick and Laura D. Gelfand, 415–45. Boston: Brill, 2011.

United States Conference of Catholic Bishops. *General Instruction of the Roman Missal*. Totowa, NJ: Catholic Book Publishing Corp., 2011.

Van Ausdall, Kristen. "Communicating with the Host: Imagery and Eucharistic Contact in Late Medieval and Early Renaissance Italy." In *Push Me, Pull You: Imaginative and Emotional Interaction in Late Medieval and Renaissance Art*, Vol. 1, edited by Sarah Blick and Laura D. Gelfand, 447–86. Boston: Brill, 2011.

Vatican Council II. *Dei Verbum* (Dogmatic Constitution on Divine Revelation). In *Vatican Council II: The Conciliar and Postconciliar Documents*. New Revised ed. Translated by Austin Flannery. Collegeville, MN: Liturgical Press, 2014.

————. *Gaudium et Spes* (Pastoral Constitution on the Church in the Modern World). In *Vatican Council II: The Conciliar and Postconciliar Documents*. New Revised ed. Translated by Austin Flannery. Collegeville, MN: Liturgical Press, 2014.

————. *Lumen Gentium* (Dogmatic Constitution on the Church). In *Vatican Council II: The Conciliar and Postconciliar Documents*. New Revised ed. Translated by Austin Flannery. Collegeville, MN: Liturgical Press, 2014.

————. *Orientalium Ecclesiarum* (Decree on the Catholic Churches of the Eastern Rite). http://www.vatican.va/archive/hist_councils/ii_vatican_council/documents/vat-ii_decree_19641121_orientalium-ecclesiarum_en.html.

————. *Sacrosanctum Concilium* (Dogmatic Constitution on the Sacred Liturgy). In *Vatican Council II: The Conciliar and Postconciliar Documents*. New Revised ed. Translated by Austin Flannery. Collegeville, MN: Liturgical Press, 2014.

————. *Unitatis Redintegratio* (Decree on Ecumenism). In *Doing the Truth in Charity*, edited by Thomas F. Stransky and John B. Sheerin, 17–33. New York: Paulist Press, 1982.

Vosko, Richard S. *God's House Is Our House: Re-imagining the Environment for Worship*. Collegeville, MN: Liturgical Press, 2006.

Walter, Christopher. "The Origins of the Iconostasis." *Eastern Churches Review* 3 (1971): 251–67. Reprinted in *Studies in Byzantine Iconography*. London: Variorum Reprints, 1977.

Ware, Kallistos. "The Hesychasts: Gregory of Sinai, Gregory Palamas, Nicolas Cabasilas." In *The Study of Spirituality*, edited by Geoffrey Wainwright, Edward Yarnold, and Cheslyn Jones, 242–55. London: SPCK, 1986.

Weitzmann, Kurt. "Icon Painting in the Crusader Kingdom." *Dumbarton Oaks Papers* 20 (1966): 49–83.

Weyl Carr, Annemarie. "Byzantines and Italians on Cyprus: Images from Art." *Dumbarton Oaks Papers* 49 (1995): 339–57.

White, Susan J. *Art, Architecture, and Liturgical Reform: The Liturgical Arts Society (1928–1972)*. New York: Pueblo Publishing, 1990.

Wixom, William D. "Byzantine Art and the Latin West." In *The Glory of Byzantium: Art and Culture of the Middle Byzantine Era A.D. 843–1261*, edited by Helen C. Evans and William D. Wixom, 434–507. New York: Harry N. Abrams, 1997.

Yazykova, Irina. *Hidden and Triumphant: The Underground Struggle to Save Russian Iconography*. Translated by Paul Grenier. Brewster, MA: Paraclete Press, 2010.

Zibawi, Mahmoud. *Eastern Christian Worlds*. Collegeville, MN: Liturgical Press, 1995.

———. *The Icon: Its Meaning and History*. Collegeville, MN: Liturgical Press, 1993.

# Photo Credits

Cover: *Sacred Heart of Jesus*. Icon by the hand of Marek Czarnecki. Photo by Phillip Fortune. www.seraphicrestorations.com. Used with permission.

Title page: *St. Luke Painting the Virgin*. Icon by the hand of Marek Czarnecki. Photo by Phillip Fortune. www.seraphicrestorations.com. Used with permission.

Page xi: *Byzantine Crucifixion*. Walters Art Museum. Wikimedia Commons. https://commons.wikimedia.org/wiki/File:Byzantine_-_Crucifixion_-_Walters_71244.jpg.

Page 1: Detail of *Sinai Christ*. Icon by the hand of Marek Czarnecki. Photo by Phillip Fortune. www.seraphicrestorations.com. Used with permission.

Pages 4–5: Photos by Marek Czarnecki. Used with permission.

Page 9: *Byzantine Icon of the Nativity*. The Byzantine and Christian Museum in Athens, https://commons.wikimedia.org/wiki/File:MCB-icon12.jpg. Used with permission.

Page 11: *Icon of St. Bede*. By the hand of the author. Photograph by Krista Hall. Used with permission.

Page 14: *Portrait of a Woman from Al-Faiyum, Egypt*. Roman Period, ca. 100–150 CE. Milwaukee Art Museum, Wisconsin. https://en.wikipedia.org/wiki/Encaustic_painting#/media/File:Encaustic PortraitWoman.jpg. Used with permission.

Page 17: Example of iconoclasm. Image by Barbara Kilise. Photograph by Antoine Taveneaux. https://commons.wikimedia.org/wiki/File:Barbara_kilise_10.jpg. Used with permission.

Page 25: Detail of *Saint Hildegard*. By the hand of Marek Czarnecki. Photo by Phillip Fortune. www.seraphicrestorations.com. Used with permission.

Page 29: *Madonna*. Painted by Lorenzo Monaco, ca. 1410, tempera on wood, Museo di Palazzo Davanzati, Florence. https://commons.wikimedia.org/wiki/File:Don_Lorenzo_Monaco_013.jpg. Used with permission.

Page 35: *Indulgenced Image of the Mass of St. Gregory*, ca. 1430. Image published by Adam Kristoffer Fabricius (July 1822–August 1902). https://commons.wikimedia.org/wiki/File:Indulgence1430.jpg.

Page 37: *Fürst der Welt*, "Prince of the World" (ca. 1310). Photo by Suzanne Karr Schmidt. Used with permission.

Page 41: *Icon of the Virgin Mary*. Chapel of St. James in the Church of the Holy Sepulchre. Photo by Deror Avi. https://commons.wikimedia.org/wiki/File:Chapel_of_St._James_IMG_0495.jpg. Used with permission.

Page 49: Detail from *Our Lady of the Sign*. Icon by the hand of Marek Czarnecki. Photo by Phillip Fortune. Used with permission.

Page 53: *Our Lady of America*. Saint Meinrad Seminary and School of Theology, Saint Meinrad, Indiana. Photo by Krista Hall. Used with permission.

Page 60: *Crucifix*, parish near Muenster Schwartz, Munsterschwarzach. Photo by Br. Martin Erspamer, OSB. Used with permission.

Page 66: Image of devotional icon. Our Lady of the Snows, Belleville, Illinois. Photograph by the author.

Page 71: Detail of *The Resurrection*. Icon by the hand of Marek Czarnecki. Photo by Phillip Fortune. www.seraphicrestorations.com. Used with permission.

Page 75: *Sinai Christ*. Encaustic icon of Christ, sixth century. Saint Catherine's Monastery, Sinai, Egypt. https://commons.wikimedia.org/wiki/File:Christ_Icon_Sinai_6th_century.jpg. Used with permission.

Page 84: *St. Peter Enthroned*. Photo by Michael Cronin. Used with permission.

Page 91: Icon at Exeter Cathedral, Devon, England. Photo by Chase Becker. Used with permission.

Page 93: Detail of *Saint Cecilia*. Icon by the hand of Marek Czarnecki. Photo by Phillip Fortune. www.seraphicrestorations.com. Used with permission.

Page 97: Apse of the Great Hall (formerly the abbey church) at Saint John's University, Collegeville, Minnesota. Photo and permission provided by Saint John's Abbey.

Page 101: Icons by the hand of Gianluca Busi. Private chapel of Cardinal Carlo Caffarra, Villa Revedin, Bologna, Italy. Image and permission provided by Gianluca Busi.

Page 105: Image of Saint John's Abbey Guesthouse Chapel, Collegeville, Minnesota. Photo by Br. Simon Hoa Phan, OSB. Permission provided by Saint John's Abbey.

Page 117: Detail of *Christ the High Priest*. Icon by the hand of Marek Czarnecki. Photo by Phillip Fortune. www.seraphicrestorations .com. Used with permission.

Page 128: *Protestant Church Inscription*. Gosau, Upper Austria. Interior of Protestant church. https://commons.wikimedia.org/wiki /File:Gosau,_protestant_church.jpg. Used with permission.

Page 130: *Title Page Border for Adam Petri's Reprint of Martin Luther's Translation of the New Testament*. https://commons.wikimedia.org /wiki/File:Luther_bible,_by_HH.jpg. Used with permission.

Page 133: *Destruction of Icons in Zurich*. https://commons.wikimedia .org/wiki/File:Destruction_of_icons_in_Zurich_1524.jpg. Used with permission.

Page 137: Warner E. Sallman, *The Head of Christ*, © 1941, 1968 Warner Press, Inc., Anderson, Indiana. Used with permission.

Page 139: *Prayer in Taizé Church*. Photo by Damir Jelic. https:// upload.wikimedia.org/wikipedia/commons/f/f6/Taiz%C3%A9 _prayer.JPG. Used with permission.

Page 141: *Christ the Bridegroom*. Icon by the hand of Marek Czarnecki. Photo by Phillip Fortune. www.seraphicrestorations.com. Used with permission.

Page 146: *Icon of St. Kateri Tekakwitha*. Icon by Marek Czarnecki. Photo by Phillip Fortune. www.seraphicrestorations.com. Used with permission.

Page 148: *Sacred Heart of Jesus and Immaculate Heart of Mary*. Icons by the hand of Marek Czarnecki. Photo by Phillip Fortune. www .seraphicrestorations.com. Used with permission.

# Index